MODERNISM

CHARLES HARRISON

TATE GALLERY PUBLISHING

Cover:
Hans Hofmann
Nulli Secundis 1964
(detail, fig.41)

Frontispiece:
Pablo Picasso
The Three Dancers
1925 (fig.42)

ISBN 1 85437 184 3

A catalogue record
for this book is
available from the
British Library

Published by order
of the Trustees of
the Tate Gallery
by Tate Gallery
Publishing Ltd
Millbank, London
SW1P 4RG

Cover designed by
Slatter-Anderson,
London.
Book designed by
Isambard Thomas

Printed in Hong
Kong by South Sea
International Press
Ltd

Measurements
are given in
centimetres,
height before width,
followed by inches
in brackets

Contents

I

What is Modernism?

Modernisation, modernity and modernism – three concepts around which thought about the modern world and its culture has tended to revolve. In the definition of the first two there is rarely much disagreement. Modernisation refers to a range of technological, economic and political processes associated with the Industrial Revolution and its aftermath; modernity to the social conditions and modes of experience that are seen as the effects of these processes. On the meaning of modernism, however, agreement is less easily secured. In general usage it means the property or quality of being modern or up-to-date. Yet it also tends to imply a type of position or attitude – one characterised by specific forms of response towards both modernisation and modernity. When the term is applied to art there are thus two problems to be faced. The first is that modernism tends not to be used as a blanket term to cover all the art of the modern period. Rather, it is a form of *value* normally associated with certain works only and serving to distinguish these from others. To pick out a work of art as exemplifying modernism is to see it as belonging to a special category within the Western culture of the modern period. Yet the works which tend to be gathered into this category are not always easily seen as connected either to processes of modernisation or to the experience of modernity. How, for instance, are we to understand the modernism of a Matisse (fig.1) or a Rothko (fig.2), if not as a form of rejection or evasion of the physical evidence of modernity?

The second problem is that there are different views about the historical positioning of modernism: about when it is supposed to have been initiated

6

1
Henri Matisse

The Inattentive Reader
1919

Oil on canvas
73 × 92.4 (28¾ × 26½)
Tate Gallery

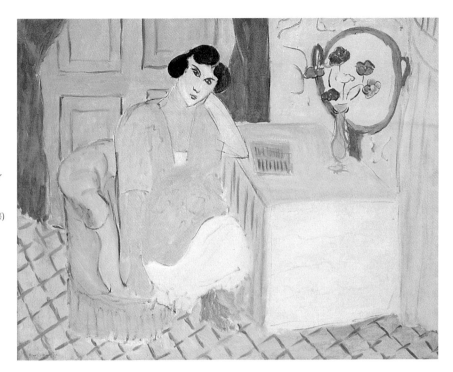

2
Mark Rothko

Light Red over Black
1957

Oil on canvas
232.7 × 152.7
(91½ × 60¼)
Tate Gallery

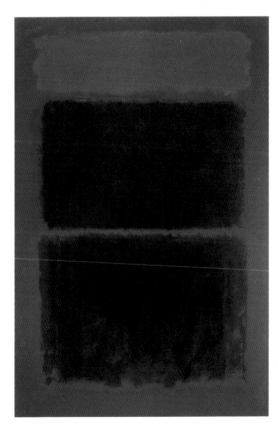

3
Georges Braque

Clarinet and Bottle of Rum on a Mantelpiece 1911

Oil on canvas
81 × 60 (32 × 23⅝)
Tate Gallery

4
André Derain

Henri Matisse 1905

Oil on canvas
46 × 34.9 (18⅛ × 13¾)
Tate Gallery

and whether it is supposed to have run its course. The origins of modernism have been variously located at times between the late eighteenth century and the early twentieth, while the recent currency of the concept of postmodernism implies either that modernism itself has run its course, or that it has become synonymous with a form of cultural conservatism – which may amount to the same thing.

It is difficult to address one of these problems without becoming caught up in the other. For instance, whether or not one regards modernism as possibly exhausted depends on what kind of value or category one believes it to be. It is just this dual implication, in evaluation on the one hand and periodisation on the other, that renders the concept of modernism hard to pin down. The same difficulty applies to the concept of Romanticism, from which modernism derives much of its aesthetic theory, and with which it overlaps in other important respects. With most of the other '-isms' agreement can normally be reached about when they are supposed to have

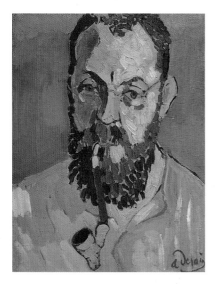

occurred without the need for agreement as to their value and significance. But as with Romanticism, to write about modernism in art is inevitably to enter an area of substantial controversy.

We should try to establish some more secure ground from which to start. It is normal to associate the modern in art with a breakdown of the traditional decorum in Western culture that previously connected the appearance of works of art to the appearance of the natural world. The typical symptoms of this breakdown are a tendency for the shapes, colours and materials of art to lead a life of their own, forming unusual combinations, offering distorted or exaggerated versions of the appearances of nature and, in some cases, losing all obvious connection to the ordinary objects of our visual experience. Thus a painting that looks like nothing on earth is liable to be categorised – on the streets at least

– as a 'modern' painting, though it may by now be the best part of a century old. To ask why this breakdown occurs when it does, and in the manner that it does, is to inquire into the historical character and form of modernism.

The works of art in which such symptoms are first unmistakably discernible were produced by avant-garde artists working in a number of major European cities in the first decade and a half of the twentieth century. It was the development of Cubism in the years after 1907 that most clearly marked a break with previous styles (figs.3, 32). In 1948 the American critic Clement Greenberg looked back to Cubism as 'the epoch-making feat of twentieth-century art, a style that has changed and determined the complexion of Western art as radically as Renaissance naturalism once did' (Greenberg 1948, in Greenberg II 1986, p.212). However different accounts of modernism may vary in their chronological span, all are agreed on this at least: that the moment of Cubism and of its immediate aftermath must be accorded a central importance.

In its origins Cubism was a Parisian phenomenon, as was the roughly contemporary tendency that came to be known as Fauvism – a tendency in which simplification of form was combined with expressive exaggeration of colour (fig.4). By the outbreak of the First World War in September 1914, however, groups of contributors to an international modern movement were to be found in Milan, Munich, Moscow, Berlin, Vienna, Prague, London and elsewhere, their related forms of avant-gardism variously incorporating, adapting or transforming more local and more traditional interests and practices. There were Futurists in Italy (fig.5) and Russia, Expressionists in Germany (fig.6), and Vorticists in England (fig.7), while the possibility of an abstract art was being pursued by individual artists in a number of different locations. The war years from 1914 to 1918 saw the beginnings of Suprematism (fig.8) and Constructivism in Russia, and the expansion of a cosmopolitan Dada movement in Zurich, Berlin, Paris and New York.

We are immediately faced with a paradox – one to which we shall need to return at various points. On the one hand there is relatively widespread agreement that such works as these deserve to be considered as forms of 'modern art'. On the other hand these same works have on the whole remained incomprehensible and in many cases unattractive to the great majority of people, who would no doubt see themselves in all other respects as qualified inhabitants of the modern world. How is it that a difficult and largely unpopular art has played so substantial a part in deciding the cultural self-image of the century?

A similar question might be asked with respect to the music and literature of the early twentieth century, in which comparable modernist tendencies may be seen at work. In studying the rise of modernism in music one might consider the breakdown of classical harmony and tonality during the later nineteenth century and the development of atonal forms by composers of the Viennese School in the early years of the twentieth. Similarly, to study literary modernism is to read the work of early twentieth-century poets who

5 *above left*
Giacomo Balla

Abstract Speed – The Car Has Passed 1913

Oil on canvas
50.2 × 65.4
(19¾ × 25¾)
Tate Gallery

6 *above right*
Ernst Ludwig Kirchner

Nude behind a Curtain (Franzi) 1910

Oil on canvas
120 × 90 (47¼ × 35½)
Stedelijk Museum,
Amsterdam

departed from conventional patterns of rhyme and metre, or of novelists whose forms of narrative seem deliberately to frustrate the accepted conventions of storytelling. The resulting works have an undeniable standing in the culture of the century, but they cannot be said to have achieved popularity. An aura of difficulty still clings to the music of Arnold Schoenberg and Igor Stravinsky, to the poetry of T.S. Eliot and to the novels of Franz Kafka and James Joyce.

On the basis of this evidence, it is tempting to conceive of modernism as a form of specifically twentieth-century cultural revolution, driven by rapid technological progress and political ferment, involving the pursuit of change for its own sake and issuing in forms of militant avant-gardism and experiment. Some of the most influential characterisations of modernism have indeed been sketched out along these lines. There is much apparently to recommend such a view. The pace of stylistic change in the arts does seem to have accelerated dramatically after the turn of the century. It is also true that relevant connections can be made between the theories that circulated in the artistic avant-gardes and those forms of social and political vision that invested the politics of the period. The Futurists in Italy and the Suprematists and Constructivists in Russia were each in their different ways anticipating forms of social and political change to which they intended their works to contribute, and by which they expected them to be justified.

But this account of modernism is in the end inadequate. It has two major deficiencies. The first is that it encourages us to think of the modern art of the early twentieth century *simply* as the artistic expression of modernity; that is to say as a form of spontaneous reaction to social conditions and historical events. We are then in danger of underestimating those concerns and problems specific to the practices and traditions of art which may also have been powerful motivating factors in the development of new forms and styles. Whether or not individual artists react to historical conditions and changes, their work is done as art, and in their thought about how this work is

7 *below left*
Wyndham Lewis

Composition 1913

Pen, watercolour and pencil on paper
34.3 × 26.7
(13¼ × 10½)
Tate Gallery

8 *below right*
Kasimir Malevich

Dynamic Suprematism
1915 or 1916

Oil on canvas
80.3 × 80 (31¾ × 31½)
Tate Gallery

to be pursued they tend to refer to other art, be it the achievements of an earlier generation, their own immediately previous production, or the enterprises of their contemporaries. Indeed, it may be precisely this recourse to the apparent intensity of other art that assures the artist of some independence of judgement and expression *in face of* social conditions and historical events. As we shall see, many of the most influential of modern art's early supporters believed that it was precisely in its independence from social concerns and processes that the value of modernist art was to be found.

The second deficiency in the account is that it encourages us to consider modernist avant-gardism in virtual isolation as the representative art of the twentieth century. The danger here is that we may come to regard modernism as a somehow 'natural' and inescapable tendency in culture, and fail to bear in mind that it was always an option among others – and one never adopted by more than a minority. We tend to assume, with some justice, that by the turn

of the century the lines of battle were clearly drawn between modernists and traditionalists. It does not follow, however, that it can always have been easy for the artist in the studio to distinguish what was and what was not a 'modern' direction to pursue, or, indeed, what might or might not constitute a 'modern' form of response to historical events. If modernism represents a form of value, it is one that was not to be achieved without thought or struggle. Nor should we assume that obscurity was an end that artists pursued for its own sake. Pablo Picasso was one of the leading figures in the Parisian avant garde during the first two decades of the century. Even during the periods when his most consistently 'difficult' works were produced we find moments of lucid conservatism or of classicism. He seems to have found it necessary at certain points to re-establish contact with that which modernism was not, as if modernism's necessity and its value were uncertain in the absence of sufficient contrast (fig.9). However we are to conceive of modernism, in other words, we need to think of it in relation to such other forms of value as art might at any given moment be thought to possess.

From these two cautions – that we should avoid conceiving of modern art *either* as merely reactive *or* as somehow isolated and unquestionable – we may derive a single more positive account of modernism. The first point to note, as already mentioned, is that the practice of art is necessarily conducted within the context of some tradition of art and with regard to other works of art. Even among the more abstract productions of the early twentieth-century avant gardes there occasionally occur forms of quotation and

9
Pablo Picasso

The Artist and his Model
1914

Oil and pencil
on canvas
58 × 56 (22¾ × 22)
Musée Picasso, Paris

10
Joan Miró

Dutch Interior I 1928

Oil on canvas
91.8 × 73 (36¼ × 28¾)
The Museum of Modern
Art, New York.
Mrs Simon Guggenheim
Fund

13

reference by which the works of previous artists are conjured up. For his *Dutch Interior I* of 1928 (fig.10) Joan Miró took as his point of departure a painting by the seventeenth-century Dutch artist Hendrick Sorgh that he had seen on a trip to Holland. The second point to bear in mind is that the value of modernism is established in practice as a kind of intentional *difference* with respect to other current forms and styles and practices. In many cases a modern work will invite comparison with some similar but more conservative manner of treating of a given subject, as if it is precisely through what is *not* shared – through the remainder that is left when all common features have been excluded – that its real meaning is to be found (figs.11, 12). Thus Cézanne regarded the works of the Academician Bouguereau as a model of what to avoid.

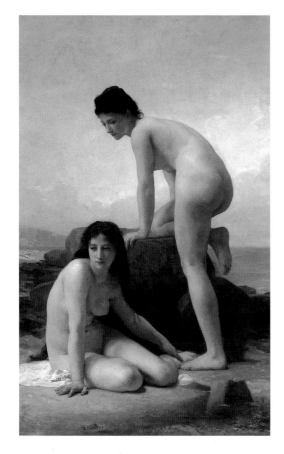

The proposition to which these observations are leading is that modernism may fruitfully be thought of as a form of tradition, but one maintained in a kind of critical tension with the wider surrounding culture. The tradition in question is one in which what is carried forward is not a given stylistic canon, but rather a kind of disposition or tendency. On this view, artists of a modernist persuasion will tend to dissociate themselves and their practices from authorised manners of seeing and picturing the world, while nevertheless seeking to maintain that independent depth and intensity of effect for which other art alone provides the measure. It follows that, whereas a form of art may be identified as *modern* on the basis of its style alone, to call a work of art *modernist* is to make a finer distinction. It is to register its appearance as significant of certain critical commitments and attitudes maintained by the artist with regard both to the larger culture of the present and to the art of the recent past. This may help to explain how significant values come to be carried through artistic works that remain unpopular in the sense of being difficult to connect to prevailing cultural interests and values. It may also help to explain why a modernist art such as Matisse's or Rothko's should appear to distance itself from those forms by which the appearance of the modern is normally defined; why, that is, their art should shows so little sign of the effects of mechanisation and the expansion of consumer goods.

11
William-Adolphe Bouguereau

The Bathers 1884

Oil on canvas
210 × 129
(82¾ × 50¾)
The Art Institute of Chicago. A.A. Munger Collection

12
Paul Cézanne

The Three Bathers 1879–82

Oil on canvas
52 × 55 (20½ × 21¾)
Musée du Petit Palais de la Ville de Paris

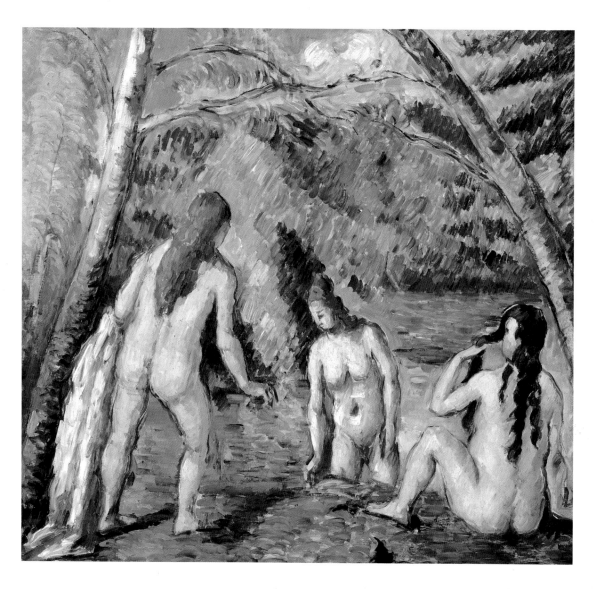

2

13
Odilon Redon

*Profile of a Woman with
a Vase of Flowers*
*c.*1895–1905

Oil on canvas
65.5 × 50.5
(25¾ × 20)
Tate Gallery

THE MODERNIST TRADITION

The principal focus of this book is on the modernist art of the late
nineteenth and twentieth centuries, but given the connection mentioned
earlier between the evaluation of modernism and its periodisation, we
should give some thought to the derivation of a modernist tradition. In
considering what this broadly involves, it is useful to bear in mind the ways
in which the modern and the classical are distinguished in the study of human
languages. A modern language is one that is still in everyday use and is thus
still adaptable and transformable for the purposes of expression. The
classical languages of ancient Greek and Latin, by contrast, are fixed into
an unchanging form by their surviving inscriptions and by the canons of
their literature. Matters are similar in the field of art. The aspiration to
modernism makes little sense if conceived of in isolation. Rather it reveals
itself in contrast with the values of some cultural tradition that the artist has
come to regard as both canonical and untransformable.

In the majority of European cultures during the seventeenth and
eighteenth centuries the classical arts of the Greeks and Romans constituted
the foundations of a continuous tradition and furnished the constant
standards by which any relevant achievement was to be measured. This art
was largely understood on the basis of surviving monuments and fragments,
while, though no Greek painting survived as such, its supposed achievements
were extrapolated from the evidence of sculpture and from suggestions
derived from classical texts. Those contemporary artists who hoped to win
the patronage of the cultured and the powerful for the most part aspired to

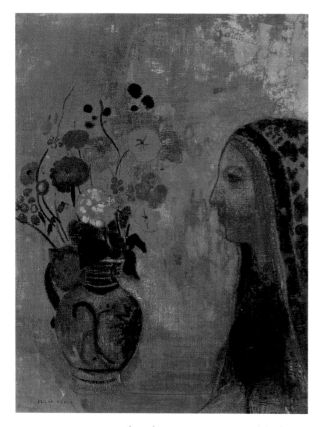

a kind of matching standard. That is to say, they submitted to the idea that the route to success in art was defined by the authority of classical exemplars and the continuity of classical principles. From the mid seventeenth century in France and from the late eighteenth century in England, this authority and sense of continuity were principally vested in Academies (the Académie des Beaux-Arts in Paris and the Royal Academy in London), which also had the important function of representing standards of professional competence to potential purchasers and patrons.

Under such circumstances, what might it mean for an artist to conceive of a 'modern' art as some form of alternative? The first thing we could say about this artist is that he or she must have come to experience the inherited language of art as unchanging and unchangeable, and in that sense as unsuitable for any spontaneous or individual form of expression. In pursuing the idea of a 'modern' art, this artist would thus be motivated both by frustration at the rigidity and impersonality of the ruling grammar and vocabulary of art, and by a certain determination regarding the currency and difference – the individual value – of that which he or she had to express. This is indeed how it seems to have been. By the end of the nineteenth century it had become a virtual convention that to express just such a mixture of frustration and determination was to proclaim the 'modernism' of one's disposition. This is the French artist Odilon Redon (fig.13) looking back to the time of his studentship in the 1860s:

> The teaching I was given did not suit my nature. The professor had for my natural gifts the most ... complete lack of appreciation ... I saw that his obstinate eyes were closed before what mine saw ... Young, sensitive, and irrevocably of my time, I was there hearing I-don't-know-what rhetoric, derived, one doesn't know how, from the works of a fixed past ... No possible link between the two, no possible union. (Redon 1922, in Rewald 1961, p.73)

As this passage makes clear, the aim to be 'modern' typically grew from some sense that the present was being unduly shaped in the image of the past, and from some consequent loss of identification with the dominant tendency of the culture. It is reasonable to assume that where that loss was significant in terms of the production of distinct alternative forms of art, it cannot simply have been the experience of a few socially maladjusted individuals

(or 'geniuses'), but must have coincided with some larger change of self-image in a substantial section of society. If modernism was unacademic in its origins and in its development, then, as it generally was, this was not simply because certain artists were unwilling to conform to classical styles. It was because the entire mode of existence within which modernist critical intuitions were realised was incompatible with the world of values that the Academies were there to represent. Under such circumstances academic standards were bound to appear at best inadequate and at worst decadent and oppressive (as they already did, for instance, to the Romantic William Blake at the turn of the eighteenth and nineteenth centuries). The would-be modern artist must then look elsewhere than the authorised classical tradition – into other reaches of the culture or into other cultures altogether – for models to emulate and for measures of aesthetic achievement.

To think of modernism in these terms is to suggest a strong alternative to the identification of modernist art simply with the avant-garde enterprises of the early twentieth century. As implied earlier, it involves recognising a tradition of modernist sensibility with some specific moral and intellectual building blocks, which can be traced back to the period of the late eighteenth and early nineteenth centuries. This is the period that embraced the European Enlightenment, the French Revolution, and the rise of Romanticism in Germany. In the advanced thought of this period certain major tendencies may be noted that were to remain consistently relevant to the pursuit of modernism in all the arts. Though these tendencies were closely interconnected, I shall single out four for the sake of clarity.

The first tendency is confidence in the possibility of progress and betterment in human societies, to be brought about through the exploitation of technological advances and the application of rational principles. In the Kantian philosophy of the time, it was seen as an inescapable obligation of the educated that one should strive for the elimination of error through processes of rational self-criticism. The second tendency is a determination to break with the legacy of classicism in its aristocratic forms (though not, it should be noted, with the supposed classical ideal of a republican freedom). For the French Enlightenment critic Denis Diderot, a 'modern' taste was one that self-consciously distanced itself from the decorative neo-classical modes of the *ancien régime*. The third tendency is a commitment to scepticism in the face of received ideas and beliefs, however apparently authoritative, combined with an inclination to regard direct experience as the true source of knowledge. For the Empiricist philosopher it was incumbent upon the responsible individual to seek emancipation from superstition, and to suspend a given belief if no relevant observation and experience could be adduced to confirm it. (This grounding in Enlightenment scepticism helps to explain modernist art's virtually complete disengagement from traditional religious themes.) The fourth tendency, associated particularly with the Romantic movement, is to stress the role of the imagination in safeguarding human freedom and in realising human potential. It could be said of this last tendency that it represents a synthesis of all the others. The capacity to imagine a different order of things is a necessary condition of critical and

self-critical activity. It is a form of creative projection in thought, which is mere idealism unless it is grounded in those values that one's direct experience confirms. (Though this understanding of imagination may not be entirely standard, it is central to the development of modernism, as I hope to show.)

To apply the concept of modernism to the history of art, then, is to refer to a tendency that accords priority to the imagination as thus defined, that is affirmative of the value of direct experience, and that is critical of ideas that remain resistant to change. As implied earlier, we should not expect to be able to identify a specific modernist style. Rather, modernist art will tend to define itself by reference to the kinds of style from which it establishes its difference. In fact, we might say that one of the identifying signs of a modernist art will be a kind of scepticism or wariness about *any* fixed relationship between a picture and its subject – a form of self-consciousness, in other words, about *how* the picturing is done. In the classical art of the eighteenth century and in the academic art of the nineteenth, technique was conceived of as a means to realise a subject. It was assumed that, at the point at which that realisation was achieved, technique as such would cease to be noticeable. It would, as it were, be seen through. It is a distinguishing feature of modernism, as we shall see, that its technical means can no longer be allowed to become transparent.

This distinction between pre-modernist and modernist art was described by Clement Greenberg in terms that have been much quoted:

> Realistic, naturalistic art had dissembled the medium, using art to conceal art; Modernism used art to call attention to art. The limitations that constitute the medium of painting – the flat surface, the shape of the support, the properties of the pigment – were treated by the Old Masters as negative factors that could be acknowledged only implicitly or indirectly. Under Modernism these same limitations came to be regarded as positive factors, and were acknowledged openly … Whereas one tends to see what is in an Old Master before one sees the picture itself, one sees a Modernist picture as a picture first … (Greenberg 1960, in Greenberg IV 1993, pp.86–7)

The essay from which that quotation is taken was first issued under the title 'Modernist Painting' in 1960. Greenberg's ideas have had so strong an influence on thought about the nature of modernism that no discussion of the subject can proceed far without some acknowledgement of them. By means of what he represented as a 'logic of development', Greenberg aimed to connect a series of decisive judgements in favour of individual artists to a retrospective view of modernism as a historical phase or period in western culture. In Greenberg's view all that was 'truly alive' in modern culture was possessed of a self-critical aspect, that he traced back to the Enlightenment. In Greenberg's view this aspect was not to be identified with the imagery of a work or with such descriptive or narrative content as it might possess. On the contrary, it was revealed in each art through a kind of concentration upon those technical considerations that were specific to the medium. According to the logic of development Greenberg perceived, 'Each art had to determine, through its own operations and works, the effects exclusive to itself.' In each

art, it emerged, these effects 'coincided with all that was unique in the nature of its medium.' So far as painting was concerned, the unique property was its flatness. Accordingly, 'Modernist painting oriented itself to flatness as it did to nothing else' (loc. cit.).

We should not be surprised to discover that the artists connected together in Greenberg's canon are those whose works can be made to tell a story of progressive flattening of the apparent pictorial surface and, by implication, of progressive loss of figurative form and content. This story begins in the 1860s with the French painter Edouard Manet (fig.14), whose works 'became the first Modernist pictures by virtue of the frankness with which they declared the flat surfaces on which they were painted' (ibid., p.86). It continues with the Impressionists and with Paul Cézanne, and runs on via the Cubists and Henri Matisse, Joan Miró and Jackson Pollock (fig.45), to Kenneth Noland (fig.48) and Morris Louis (fig.52), these last being the painters by whose current work Greenberg's critical attention was engaged at the time he was writing his essay.

It should be made clear that the account 'Modernist Painting' provides is an account of *high* art. The logic of development that Greenberg observes may be applied specifically to painting, and in general terms to sculpture, and to the kinds of music and literature sometimes described as 'serious', but it is capable of being extended into the larger culture only in negative terms. In other words, in identifying modernism both with forms of high art, and with all that is 'truly alive in our culture' (ibid., p.85), Greenberg was consigning popular culture and mass culture to the realms of the culturally inert. This position is consistent with the conclusions of his much earlier essay, 'Avant-Garde and Kitsch' of 1939, in which he proposed that the role of the avant-garde was 'to keep culture *moving* in the midst of ideological confusion and violence' and in face of the habituating effects of kitsch (Greenberg 1939, in Greenberg I 1986, p.8). Under the heading of kitsch – 'the epitome of all that is spurious in the life of our times' – Greenberg conflated the works of the modern academy with the synthetic products of urbanised mass culture (ibid., p.12).

Of course, influential as Greenberg's analysis has been, some strong objections have been raised to this account of the culture of the past two hundred or so years. Though 'Modernist Painting' was not explicitly written as an argument for abstract art, it is hard to see how painting's traditional figurative themes could survive the kind of reductive process Greenberg appears to propose as inescapable. Many people have been unwilling to accept the consequent association of modern high art with abstract painting and sculpture. For others, no theory of modernism could be acceptable that distinguishes between the values of modernist painting on the one hand and popular culture on the other in terms so apparently unfavourable to the latter. Even those who find themselves in broad agreement with Greenberg's judgements about which are the most important painters of the period may still find themselves unable to agree with the terms in which he connects them together: the logic of development by which painting is supposed progressively to purge itself of imagery, detail and depth in pursuit of a kind

14
Edouard Manet
Le Déjeuner sur l'herbe
1863
Oil on canvas
208 × 264 (82 × 104)
Musée d'Orsay, Paris

of reductive 'purity'. It has often been noted that Greenberg's 'logic of development' is only confirmed by the evidence of painting if one allows that the apparent exceptions – those artists, such as Salvador Dalí, who continue throughout the mid-twentieth century to employ roundly modelled forms and deep illusionistic spaces – do not in fact achieve 'major' status, and thus need not even be taken into account.

For those concerned to maintain traditional values in one form or another, and for all those who stand outside the framework that Greenberg proposes, modernist art as he describes it must appear merely as one form of practice among many; one, moreover, that seems to deal dismissively with just those competences in illusionistic picturing that many people continue to expect of art. Such people are likely to view those adopting this framework as themselves caught up in – and preaching – a form of 'Modernism'. The

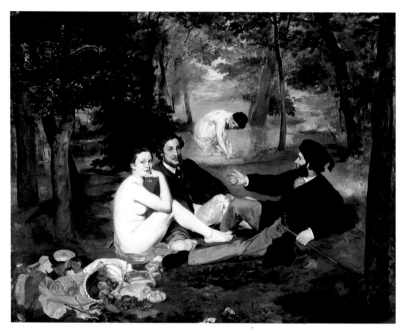

important lesson here is that to talk of modernism is not necessarily to refer only to a form of the practice of art. Increasingly since the early 1960s, the term Modernism has been used to label a specific tradition and tendency in criticism – one in which the art of the modern period is viewed and represented in a way consistent with Greenberg's theories and judgements. We shall look

more closely at the character of this critical tradition in Chapters 5 and 6, and will give some further attention to Greenberg's account of modern art in chapter seven. Meanwhile, my aim will be to employ a form of 'Modernist' view on the painting and sculpture of the late nineteenth and twentieth centuries, so as to single out a specific artistic tendency or tradition characterised along 'Modernist' lines. I shall also try to stand back from that view, however, so that the particular judgements and assumptions it involves may be held up to scrutiny. The terms 'Modernism' and 'Modernist' will henceforth be capitalised whenever I mean them to be understood primarily as referring to a critical rather than an artistic tradition or point of view. As will become increasingly clear, however, it will not always be possible or useful to distinguish the tendencies of artistic practice from those of criticism.

3

15
James Abbott McNeill Whistler

The White Girl (Symphony in White, No. 1) 1862

Oil on canvas
214.7 × 108
(84½ × 42½)
National Gallery of Art, Washington D.C. Harris Whittemore Collection

Self-Consciousness and Scepticism

If the roots of a modernist tradition can justifiably be traced back to the end of the eighteenth century, Greenberg's identification of Manet as the 'first Modernist painter' suggests that the disposition modernism represents took some considerable time to achieve a practical outcome in art. It also suggests that the moment of that achievement, when it came, was such as to be precisely pinpointed. Both suggestions deserve to be treated with some caution. Forms of academic practice certainly remained predominant during the first half of the nineteenth century, supported for the most part by aristocratic patronage and, increasingly, by governmental agencies and by those who had made commercial fortunes. But, as I have suggested, many of the priorities and commitments of which a modernist tradition was to be composed were worked out gradually during the same period. During the second decade Caspar David Friedrich in Germany and John Constable in England produced landscape paintings of great aesthetic power that were largely independent of the ordering principles of classicism. Friedrich instilled his work with romantic psychological resonance. Constable appeared to derive his pictures from a resolutely empirical regard upon the natural world, thereby risking the criticism that his work was insufficiently 'artistic'. During the 1820s and 1830s a number of French artists looked outside the European tradition for points of reference. Notable among them, Eugène Delacroix brought a decidedly unclassical exoticism of colour and painterly texture to the treatment of North African and Middle Eastern themes. And in the 1840s and 1850s a new social constituency found

representation in the Realist paintings of Gustave Courbet. Though often sentimentalised in the Academies, the peasantry of the French countryside and the marginalised poor of the European capitals had themselves remained untouched by the decorum of the classical. In the mid century they began to appear in painting as it were on more equal terms with the genteel spectator.

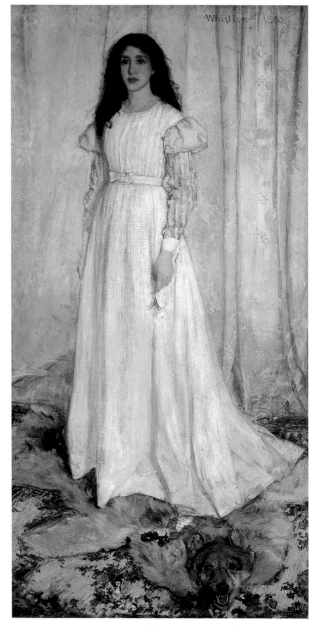

This new form of their appearance was a sign, often threatening to that spectator, that the social forces and tensions by which modernism itself was impelled were being brought closer to the surface of the art. We might also note that the five volumes of John Ruskin's *Modern Painters* were published in England between 1843 and 1860, and that the principal focus of his endeavour was the work of J.M.W. Turner, while the French critic and poet Charles Baudelaire issued his call for a 'painting of modern life' in reviewing the French Salon of 1859.

There is plenty of evidence, in fact, to show that the gap between classical and modern forms of artistic practice was widening gradually as the nineteenth century progressed. It could be said, however, that the *distinctness* of the modernist disposition was first made fully and self-consciously palpable during the 1860s, when Manet's paintings came to public notice. The French Salon of 1863 marked a clear and public point of schism; or rather what most tellingly and publicly revealed the schism was the contrast between the official Salon and a Salon des Refusés (Salon of the Rejected), set up by the French Emperor following protests at the extent and nature of the exclusions from the Salon in that year. The jury had rejected some 60 per cent of the works submitted. The apparently liberal justification for showing these works in a Salon des Refusés was to enable the public to judge for itself. Manet was one of those who elected to have his rejected works thus exhibited, *Déjeuner sur l'herbe* most notorious among them (fig.14).

James McNeill Whistler was happy to leave his painting *The White Girl* (fig.15) to this alternative form of adjudication. Camille Pissarro and Paul Cézanne were among the other exhibitors. With the benefit of hindsight we can conclude that, by 1863, those liable to be excluded from the principal professional forum on the grounds of incompetence included a significant number of the painters we now esteem most highly among the artists of their time. What this suggests is that conflicting forms of valuation were at work within the wider culture of art. Another way to put this might be to say that by 1863 – in France at least – it was becoming clear that taste in art was no longer something that one dominant section of society could define and control.

Even with hindsight, though, the Salon des Refusés should not be thought of as a straightforward triumph for the values that we now associate with modernism. A high proportion of the three thousand rejected works must have been unsuccessful attempts to produce normally academic pictures. In leaving their own paintings to be exhibited with these, painters such as Manet and Whistler took the risk that their work would be seen by the visitors to the Salon des Refusés as what it had been deemed to be by the Salon jury: incompetent *rather than* modern. The risk, in other words, was that the critical difference of their own paintings would fail to register – as it no doubt did for the great majority of visitors. What, then, was the nature of this difference? How did it make itself manifest? And how was it that the works of Manet, and even more improbably of Cézanne (the merits of whose work Manet himself was unable to accept), came in the end to be seen not simply as competent, but as possessed of abiding value? In addressing the second of these questions we provide ourselves with the key to the other two. If we can explore the distinctive effects of these works, we will be in a better position to appreciate their departure from contemporary norms. We may also begin to understand why it is that they tended to remain of interest and value as the works of more immediately successful artists came to be disregarded.

What we are considering, in effect, are the reasons for modernism's establishment as the representative art of the modern period. In pursuit of this inquiry, then, I want to consider two paintings produced within a few years of each other in the mid-1870s, one by Manet (fig.16), the other by Carolus Duran, a painter whose work was more consistently deemed acceptable in the Salon (fig.17). I have chosen them because they are similar in many respects. Each uses a landscape format to picture a full-length and near life-size figure of a woman in a lounging pose. In both pictures the woman appears to look out so as to engage the eye of the spectator, or rather of some imaginary person whose presence the composition seems to presuppose.

Another way to put this last point would be to say that each painting offers its actual spectator an imaginary role as the woman's interlocutor. In exploring the differences in these imaginary roles and in the means of their construction, we immediately confront some marked differences in effect between the two pictures. In the case of the Carolus Duran we are invited to look through the surface of the painting in the manner Greenberg associated with 'realistic, naturalistic art', and as it were to project ourselves into the

16
Edouard Manet

Woman with Fans (Nina de Callias) 1873

113 × 166.5
(44¾ × 65½)
Musée d'Orsay, Paris

17
E. Carolus Duran

Mademoiselle de Lancey c.1876

Oil on canvas
157.5 × 200
(62 × 78¾)
Musée du Petit Palais de la Ville de Paris

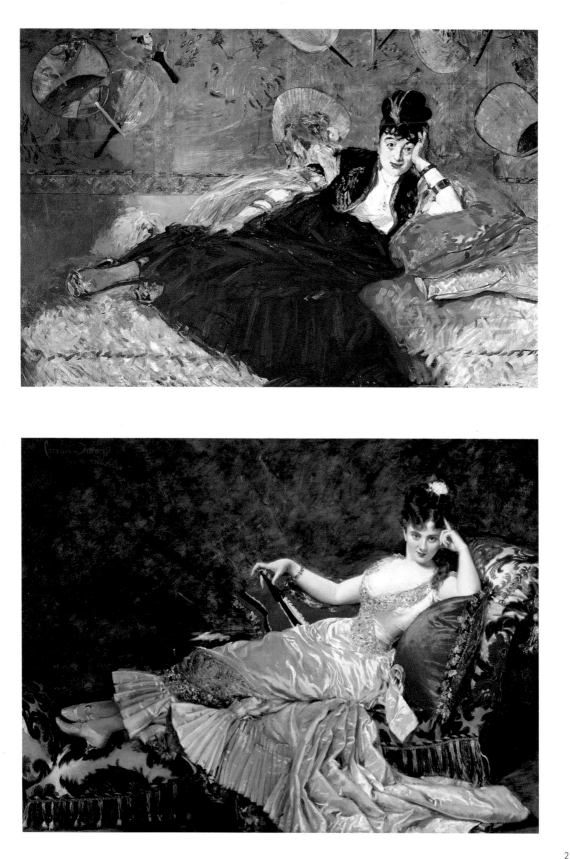

space the woman is shown to occupy. To linger too long on the means by which the illusion is sustained – the modelling of her figure, the techniques for depiction of satin and pearls – would be somehow to lose sight of the rounded figure in her shadowy space, and to step outside that state of mind in which her identity and character impress themselves upon us. With Manet's picture it is different. The eye level is set slightly lower, the figure slightly closer within the pictorial space. Small as these differences are they are sufficient to locate the spectator as it were on level terms, very close to the picture plane (the notional 'front' of the represented space) though firmly this side of it. The relative shallowness of the picture space serves to emphasise a feeling both of proximity and of self-awareness on the spectator's part, while the frankness with which the illusion is achieved seems consistent with the apparently unassuming character of the figure we confront.

If we were to sum up these differences in effect, we might say that while Carolus Duran's picture sets its subject up to be seen and addressed in a flattering manner, Manet's treats viewer and subject as potentially equal partners in a social exchange. Such an assessment would certainly fit with what can be discovered about the respective subjects of the two paintings. Mlle de Lancey was an actress, whom Carolus Duran must have been commissioned to represent in the style of a society beauty. Manet's subject, Nina de Callias, was a friend of the artist, a socially independent woman who was hostess to gatherings of the literary-artistic circles in which he moved.

There are two points to note here. The first is that in each case the form and composition of the picture serve not simply to describe a certain subject – the depicted woman – but also to place the spectator in a specific imaginary relationship with that subject. In fact we might now redefine what we mean by 'subject-matter', so that it includes not simply *what* is pictured, but also the form of effect on the spectator's imagination that follows from *how* the picturing is done. Thus one effect of the more noticeable brushwork of Manet's painting is to stress the spectator's implication in what the picture shows.

The second point is that while some paintings, like Carolus Duran's, invite us to project ourselves through their transparent surfaces and to become the guests of their fictional spaces, others, like Manet's, seem rather to act upon the space we are already occupying, and to require that we redefine our self-consciousness in their own – often quite specific – terms. Now whether or not we can apply this distinction over works from earlier periods, it seems to have been only during the mid-to-late nineteenth century that it became an issue of critical importance. It is as if the person for whom Manet was painting was someone to whom the social reality represented by the portrait of Mlle de Lancey was no longer plausible or attractive. To say this is also to say something about where we should look for explanation of the differences in question. It is to suggest that we should think not simply in terms of developments in the art of painting, but rather in terms of larger social and cultural changes – processes and consequences of modernisation – by which painting itself was bound to be affected. The specific kinds of change I have

in mind, of course, were those that might be said to define the experience of modernity. These were the changes that bore down upon people's sense of themselves as this was given by their immediate social and physical environment: by the nature of their relations with others and by their experience of urban or suburban or rural life. The distinguishing factor in what we come to see as modernism, however, is that rather than simply reflecting these changes, it involves some form of reflection *upon* them: the assertion of a position – a critical self-consciousness – in the face of modernity.

Here, then, is the point at which a gap seems to open between modernism and modernity. Modernism was not to be the mere passive expression of the experience of modernity. Rather it was to stand for the attempt to secure some independence of thought and value – some autonomy – in the face of that experience. The self-image of the modernist, as thus constructed, depended upon the maintenance of some sense of distance from those seen as the typical representatives of the modern: those, that is to say, who were either the agents or the patients of modernisation.

So far as the practice of art was concerned, what this distancing process involved was a kind of sceptical *unfixing* of those kinds of stable relations between subject and spectator that works of art had previously tended to assume. Manet's *Déjeuner sur l'herbe* was scandalising not because it pictured a typical form of modern social situation, which it did not, nor because it offered a realistic account of some exciting bohemian alternative. Rather its disturbing effect upon the viewer was to make present to the imagination just those components that modern social life could not in practice allow together – nudity and modern dress among them. (For those in a position to recognise his quotations, the ironies of Manet's painting were clear enough. Its general theme referred to the classical type of the *fête champetre,* in which it was normal for dressed and undressed figures to be gracefully combined, while the main figure group was posed after a composition attributed to Raphael.) This may finally help us to understand just why it was that works such as this were in the end distinguished from among the host of other contemporary works with which they invited comparison. The interesting difference of Manet's paintings registered with those whose responses to processes of modernisation and to the experience of modernity were already mixed. In serving to distinguish the idealised imagery of the past from the uncomfortable appearances of the present, the occasions of intimacy from the occasions of alienation, they seemed to speak to and to encourage an alertness to the complex *character* of the modern, at least in the eyes of those who now took the opportunity to advance themselves, through acts of criticism, of entrepreneurship or of patronage, as the competent judges of the art, the music, the literature and the manners of the present. This is to imply that the success of modernist art may be associated with the coming into being of a distinct 'modernist' constituency, a constituency whose critical values it helped to define by giving them imaginative form. From the mid nineteenth century until at least the late twentieth, no single factor served more consistently to identify the members of this constituency than their

concern to distance themselves from the normal tastes and values of 'the bourgeoisie'. It should be noted, however, that they themselves had no other class to belong to. The aristocracy could not be entered at will, and was anyway in decline as a force in the determination of culture, while to be a writer, a patron or an entrepreneur was by definition to rule oneself out of the working class. If the members of the modernist constituency were to

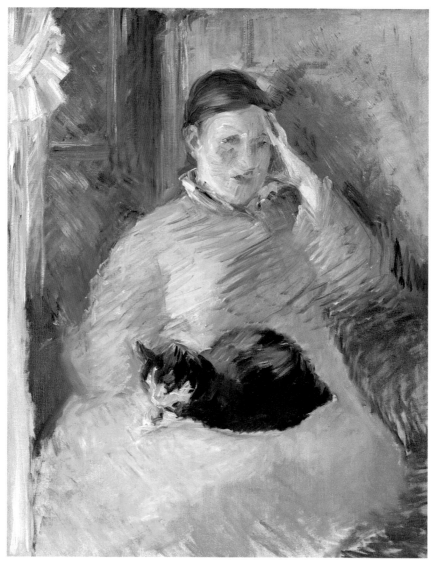

18
Edouard Manet

Woman with a Cat
*c.*1880

Oil on canvas
92.1 × 73 (36¼ × 28¾)
Tate Gallery

maintain a sense of their own distinctness, then, they must continually demonstrate the *exceptional* character of their own tastes and interests. Under these conditions, it is not hard to see just how useful an apparently difficult and unpopular art might prove to be.

 I have made considerable use of the idea that there is a form of imaginary experience that Manet's art solicits and defines. I suggested in the previous chapter that emphasis upon the critical and self-critical function of the

imagination may be seen as central to the tendency of modernism. We can now expand on this suggestion along the following lines. Modernist painting puts into effect a distinction between wanton self-projection or fantasy on the one hand and critical self-awareness or imagination on the other – a distinction that is necessary both to its own aesthetic ends and to the self-image of the public it attracts. To signal the appropriateness of its project the modernist work may need to establish some form of reference to the surrounding culture. But the distinction it has to offer is made not simply in terms of what it is that the modernist picture shows. More significantly it is made in terms of the kind of *self-conscious* activity it defines – and defines as *modern* – for the spectator. It is thus first and foremost through the manifest forms of its composition – not simply through its depicted subject, but through forms of practical negotiation between that subject and the decorated surface – that the modernist work of art serves to position its paradigm spectator relative to the emotional and intellectual manners of its time. Thus we might associate the property of modernism with the generation of a kind of scepticism in the spectator. What distinguishes the modernist work from the merely contemporary, we might say, is that it makes involvement with the procedures of representation a *condition of valid response* to whatever it is that is represented.

In the late picture of his wife, now in the Tate Gallery (fig.18), we can see the technical implications of Manet's modernism pursued to a point where the demand made upon the spectator is palpable and severe. The painting stimulates our habitual strivings to detach the image from the painted surface, and thus to make it correspond to our stereotypes of solid and comfortable domesticity. But Manet stimulates these strivings only to depreciate them. For all its lifelikeness, the image never quite loses its sheer artificiality. Hard as we may try to imagine the actual figure in its homely setting, we find ourselves caught up in the very process of its fabrication. To experience the painting in this manner, *as a composition*, is to comprehend the kind of work that is required in order to see and to represent without sentimentality. There is satisfaction of an aesthetic kind in this comprehension, but it is not a feeling we can carry back with any reassurance to the normal contexts of our own social existence. As the modernist poet T.S. Eliot was to observe, 'Human kind cannot bear very much reality'.

4

19
Claude Monet

Autumn Effect at Argenteuil 1873

Oil on canvas
55 × 74.5 (21¾ × 29¼)
Courtauld Institute
Galleries, London

20
Camille Pissarro

Misty Morning at Creil 1873

Oil on canvas
38 × 56.5 (15 × 21½)
Frau Marianne and
Dr Walter Feilchenfeldt,
Zurich

EFFECTS AND SENSATIONS

If scepticism was one side of the modernist coin in the later nineteenth century, confidence in the validity and originality of sensory experience was the other. The experience in question was not just conceived of as physiological, however, like sensations of warmth or coldness. It was conceived of as informing, and in particular as informing to the imagination. The claim that Impressionist painting still makes upon our attention, for example, is not that its themes and motifs are original inventions, but on the contrary that its various effects have their origin in the 'truth' of sensation, whether it be the kaleidoscopic effect of sunlight upon broken water (fig.19), or the muffling effect of mist over fields (fig.20). Sensation is assumed to be 'true' because it is involuntary and thus unquestionable. The implication is that it is only through a determined exposure to this 'truth' that we can come to perceive the falsehood and *un*originality of conventional pictures – those, that is to say, that have their origins not in nature but in habit and authority.

The artists who were to be known as Impressionists first showed together in an independent exhibition in 1874. Conservative responses were predictable and predictably dismissive, but the many favourable responses to the show offered further acknowledgement of the critical difference that had been observable among the 'Refusés' eleven years before. Several years later the Impressionist Camille Pissarro explicitly identified the gradual modelling and subdued chiaroscuro of the Salon painter with the 'falsehood' of bourgeois social life. By contrast he attributed a democratic virtue to the form of late-Impressionist painting that realised itself as a series of coloured

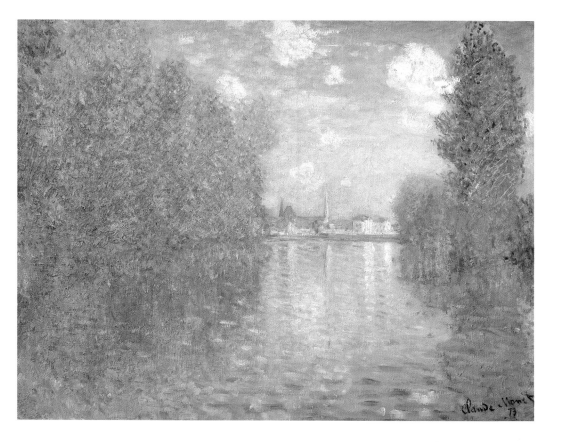

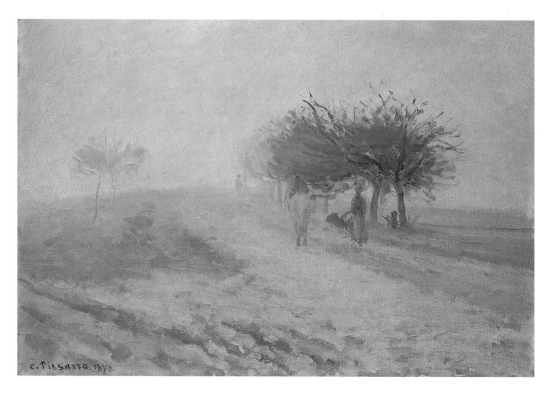

touches derived from the empirical perception of the world. These touches were to blend not upon the canvas itself, but in the process of vision, thus producing in the experience of each alert spectator an active equivalent to the original sensation (fig.21). The optical vibrancy of the canvas, Pissarro believed, was the proof of its integrity – of its being based in actual sensation and not in some form of cultural decorum.

For Pissarro the integrity of Impressionism was assured by the manner of its picturing of a world conceived essentially as social. It is clear, however, that there were other implications to be drawn from the painterly exploitation of an enhanced range of colouristic effects. After the 1880s Pissarro's fellow Impressionist Claude Monet devoted his attention to an increasingly limited range of naturalistic motifs, each studied with intense concentration under differing conditions of light and atmosphere: rows of poplars, grain stacks, river valleys, and finally the lily ponds that occupied him continuously between the 1890s and his death in 1926 (fig.22). The human figure is conspicuous by its absence from these pictures, nor do they seem to touch in any evident way upon the world of human concerns, unless, that is, that world is open to being reconceived as one in which the paramount issue is the vividness of naturalistic effects and the qualitative character of human sensory experience.

At this point we may notice what begins to look increasingly like a conflict of priorities within the broad project of modernist painting – a conflict between its pursuit of pictorial sensations and effects on the one hand and its commitment to a realist legacy on the other. The aspiration to realism had

22
Claude Monet

Waterlilies c.1916–20

Oil on canvas
200.7 × 426.7
(79 × 168)
National Gallery,
London

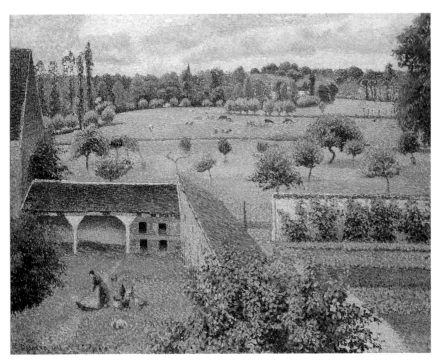

21
Camille Pissarro

*View from my Window,
Eragny* 1886–8

Oil on canvas
65 × 81 (25¾ × 32)
The Ashmolean
Museum, Oxford

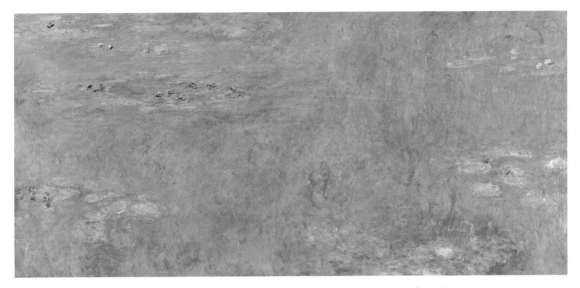

been instrumental in forming the distinctive character of modernist painting in the 1860s and 1870s. Even where it was not carried through in practice that aspiration continued to work within the conscience of modernism well into the twentieth century. How we conceive the broad history and development of modernism is thus likely to be affected by our understanding of the nature of this seeming conflict of priorities. It follows that we should give some thought to the issues at stake.

At a simple level the realism of a work of art is measured by testing its appearance against the appearance of the world, in order to see how accurately it matches. But it had been made inescapably clear in the art of Gustave Courbet between the late 1840s and the early 1860s that there can be no assessment of the truth of appearances without some consideration of what it is – and who it is – that is allowed into the field of vision in question. For those who responded positively to Courbet's work, realism could no longer be conceived of as the achievement of pictures that were true likenesses in the sense that a photograph might be said to be. (Indeed, it could be argued that it was in part photography's increasing efficiency and economy in the production of likenesses that impelled painters to reconceive the pursuit of realism in terms of the *means* of representation.) What now seemed to be required was inquiry into the matter of whose notion of 'truth' the match with appearances was supposed to serve. In painting, the evidence of this inquiry was presented through a series of implied juxtapositions of the kind we have seen at work in the comparison between the *Woman with Fans* and the portrait of *Mlle de Lancey*; juxtapositions in which significance may be drawn not simply from a given set of appearances, but from the means of their constitution. The realism of a work, in other words, is a relative critical function, that operates upon the imagination of the spectator with regard to some comparable form of picture. The effect of the realist work is to reflect the unflattering light of its own scepticism upon this other picture, whether it be one defined in paint or merely held in the mind in the form of a stereotype. The spectator projected into a state of critical self-awareness under these

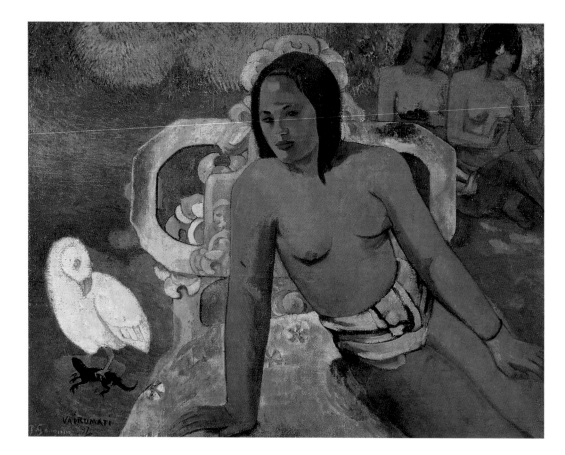

conditions is as it were directed back to some relevant portion of the world and invited to look – and to think – again.

The implication of a realist aspiration as thus understood is that it can only be satisfied when this form of reference is successfully established, which is to say when two forms of representation, the one bearing critically upon the other, are connected both to each other and to some point of reference and origin in the world. To put it another way, the possibility of realism seems to require firstly that *something* should be there to be pictured, and secondly that the *manner* in which that something is conceived and pictured should be revealing of social attitudes and commitments. According to this point of view, if a modernist form of art is to lay claim to realism, it must maintain some critical bearing upon the typical forms of modernity.

It has been noted by social historians of art, however, that much of the technical development in modernist painting from the 1880s onwards takes place with regard to motifs which are not so much distinct from the sites and occasions of modernity as categorically apart from them. It is as if modernism had withdrawn from the representation of modern social life, leaving conservative factions in unopposed command of the field. During the late nineteenth and early twentieth centuries populated landscapes, contemporary genre scenes, and pictures of social occasions both public and private continued to proliferate in conservative forms in the French Salon and

in the Royal Academy in England. On the other hand, a survey of modern French painting over the same period could be used to support the conclusion that an interest in the vividness of decorative effects – and particularly effects of colour – was to an increasing extent being pursued at the expense of engagement with the public and social aspects of contemporary life.

Such a survey might be partial, but it would range over some of the major figures in the development of modernist art. Thus it might be observed that the 'nature' that furnishes subjects for Monet's painting is apparently conceived of under an unchanging aspect; or rather, we might say that in so far as change is represented in Monet's painting it is conceived of as natural and cyclical *rather than* social and historical. It might be noted of Paul Gauguin that during the 1880s and 1890s he abandons the 'modern life' scenery of his earlier Impressionist work, in favour of the supposedly 'primitive' worlds first of rural Brittany and then of the South Seas. Meanwhile the tendency of his work is to become more powerfully decorative in its effect, as simplified and strongly modelled forms are combined with large areas of saturated colour (fig.23). At the turn of the century Pierre Bonnard (fig.24) and Edouard Vuillard (fig.25) can be seen to turn briefly back to the urban and domestic scenery of social life. Yet the most attractive of their paintings are those from which the public aspects of that life appear to be have been expunged – or in which they are perhaps taken for granted and thus cease to be visible and examinable. The optical richness of the resulting canvases may still offer proof that their effects are based on the truth of sensation, but the sensation in question is no longer one necessarily independent of the bourgeois world and its values. On the contrary, the richness and self-sufficiency of the decorative surface appear as guarantees that a pleasurable intimacy and

23
Paul Gauguin

Vairaumati 1897

Oil on canvas
73 × 94 (28¾ × 37)
Musée d'Orsay, Paris

24 *below left*
Pierre Bonnard

The Washstand 1908

Oil on canvas
52.4 × 45.5
(20¾ × 18)
Musée d'Orsay, Paris

25 *below right*
Edouard Vuillard

The Drawing Room
*c.*1910

Oil on card laid on
canvas
61.5 × 68 (24¼ × 26¾)
The Henry Moore
Foundation

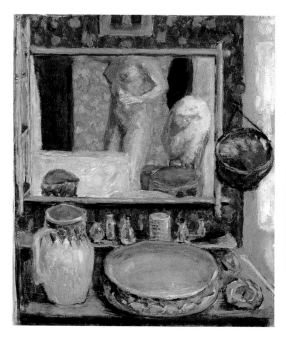

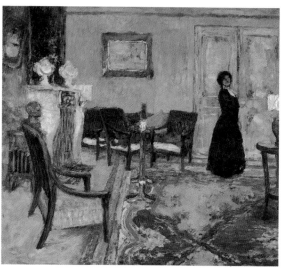

privacy may be discovered within that world. Even at the heart of the bourgeois home, perhaps especially there such pictures seem to say, one can avert one's gaze from the spectacle of social life and of modernity. And what more appropriate point to conclude this brief survey than Henri Matisse's hotel room at Nice around 1920, far removed from the metropolitan centre of avant-garde activity, where one model after another is locked into her role in the modernist decorative scheme – that sensual prison that the world of colour and form seems by now to have become (fig.26)?

This account is deliberately couched in terms that are potentially disparaging to the priorities of Modernist criticism, and as I have said, it is based on a selective review of the evidence. It would be easy enough to find exceptions: works by non-conservative artists in which the traditional preoccupations of realism are still energetically pursued. But at first sight some of the more evident exceptions do seem to prove the rule that the interests of modernism and realism tend to diverge after the 1880s. Georges Seurat, notably, attempted in the mid to late 1880s to represent scenes of modern social life in pictures whose surfaces are nothing if not optically vivid (fig.27). Whatever else these works may or may not do, they determinedly address a technical problem that stalked the development of modern painting from the beginnings of Impressionism in the late 1860s until the maturing of Abstract Expressionism in the later 1940s: how to maintain a high degree of figurative detail together with a wide chromatic range and a

26 *below*
Henri Matisse

Odalisque with Red Culottes 1921

Oil on canvas
65 × 90 (25½ × 35¾)
Musée National d'Art Moderne, Centre Georges Pompidou, Paris

27 *right*
Georges Seurat

Sunday Afternoon on the Island of the Grande Jatte 1884–6

Oil on canvas
207 × 308
(81½ × 121¼)
The Art Institute of Chicago. Helen Birch Bartlett Memorial Collection

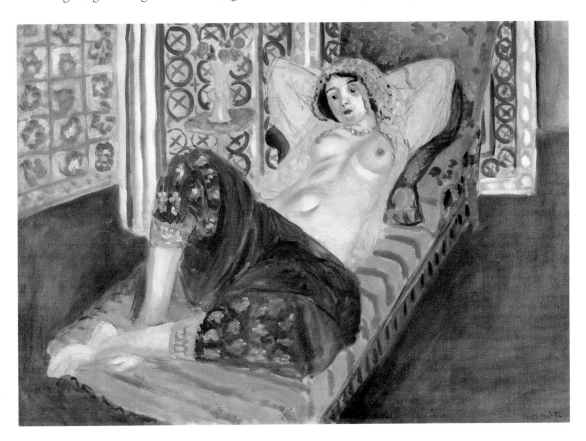

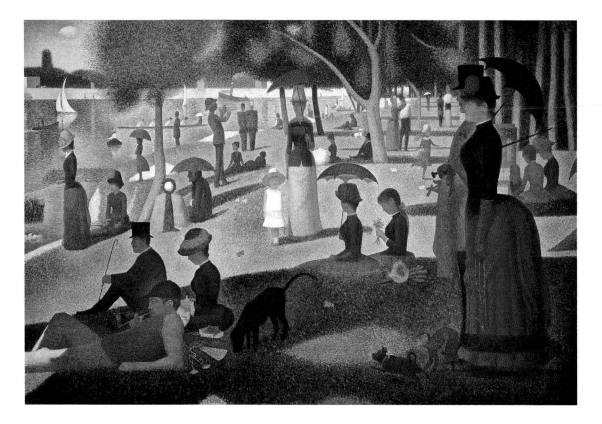

high degree of saturation of colour – which is to say how to retain 'realistic' forms of pictorial content without resorting to a conventional chiaroscuro. The tendency of the highly figurative *and* highly coloured painting is to be visually indigestible or incoherent. (There is no failing that so consistently marks the attention-seeking work of the semi-professional.) Seurat's solution was driven by a theory. He distributed colour at a consistent rate across the entire canvas by means of small and equal-sized touches. There was a price to be paid for the achievement of unification, however. The more consistently his 'Neo-Impressionist' or 'Divisionist' system was applied, the more marked the formalisation – the petrification even – of his figures. If the evidence of such work is taken as conclusive it would seem that the technical interests of modernism may indeed be reconciled with the appearances of social life, but only to the extent that one or other is allowed to be inhuman. Seurat's most readily attractive paintings are landscapes, or rather views along the margins of sea and shore, where the absence of human animation goes unnoticed and where the sense of stillness generated by the assiduous technique appears appropriate and highly expressive (fig.28).

Seurat's example was nevertheless widely followed (by the elderly Pissarro among others, as his *View from my Window* reveals; fig.21). Interest in the elimination of chiaroscuro and in the maintenance of a wide chromatic range remained dynamic factors driving change in avant-garde painting over the turn of the century. Showing together in England as neo-Realists in 1914, Charles Ginner and Harold Gilman (fig.29) sought to interpret typically

realist themes with a markedly 'modern' chromatic range, and they looked in part to Seurat for a solution to the resulting problems. However, as they and others immediately discovered, the persistence of some vitality in figurative painting required either that colours be allowed to gather into larger areas, or that the hand holding the brush be free to move at more variable speeds and in more various ways than a strict Divisionism could allow, or both. On the whole, interest in the analysis and distribution of colour proved most fertile where the relevant theories were most informally applied, as they were, for instance, in the highly coloured, loosely brushed work produced by Matisse, André Derain and their Fauve associates around 1904–6 (fig.30). It seems that we are back again with a form of art that makes no claim upon our attention so strongly as the claim it makes for its sensational character; that is to say, for the vividness and originality of its effects. But by now it seems that these effects are being conceived of as decorative *rather than* realistic.

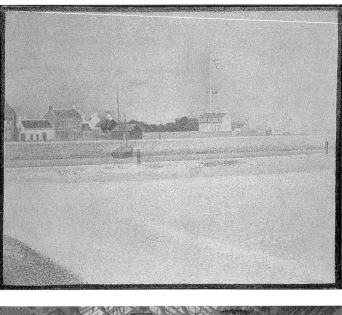

In the next chapter I wish to pursue the implications of this apparent separation between the interests of modernism and realism. I do so in order that we may come to understand why in the course of the twentieth century modernism and realism were generally regarded as antithetical.

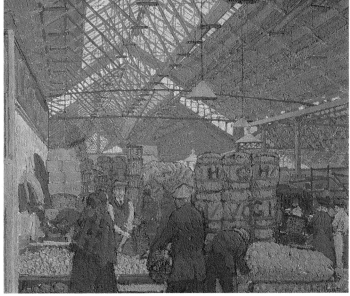

However, I mean to show that this antithesis is in the end misleading. In due course, therefore, I shall return to some of the works passed in review in this section, and will then suggest how they might be reconsidered in less disparaging terms.

28 *left*
Georges Seurat

The Channel of Gravelines, Grand Fort-Philippe, c.1890

Oil on canvas 65 × 81 (25½ × 31¾) National Gallery, London

29 *below left*
Harold Gilman

*Leeds Market c.*1914

Oil on canvas 50.8 × 61 (20 × 24) Tate Gallery

30 *right*
Henri Matisse

André Derain 1905

Oil on canvas 39.4 × 28.9 (15½ × 11½) Tate Gallery

5

SIGNIFICANT FORMS

As I noted, the account offered at the conclusion to the last chapter was cast in terms foreign to the enterprise of Modernist criticism. My aim was to indicate the possible grounds of a continuing controversy over the interpretation and evaluation of the modern development. The issue we need to bring out into the open at this point is the nature of the relationship between that development and the Modernist critical tradition by which it has been represented. Our retrospective understanding of the modernist tendency in art has inevitably been formed to a large extent by the efforts of its most effective supporters. But the very effectiveness of their advocacy has led to some questioning of the judgements by which it has been motivated, and thus to a reconsideration of much of the art in question. In this and the following chaapters, therefore, I mean to review the development of art in the twentieth century with regard to the principal priorities of Modernist criticism and theory. In due course, I shall also consider some objections that have been raised to the Modernist account of art.

What we think of as the Modernist critical tradition had its roots in the work of those nineteenth-century French writers who supported the work of Manet and the Impressionists, and it was developed by adherents to the Symbolist movement of the 1890s. But much of the subsequent work of characterisation of a modern tendency was done by English and American critics in the period between the turn of the century and the 1960s. Notable among these were Clive Bell, Roger Fry and Clement Greenberg. Their writings gave a specific 'Modernist' cast to modern thought about art.

Modernist criticism has in many ways been highly instructive. Like all criticism, however, it is open to re-examination.

In the late eighteenth and nineteenth centuries many of the greatest writers on art were 'critical historians', for whom the processes of retrospection and discrimination were to all intents and purposes inseparable. For most of the twentieth century, however, the critic and the art historian tended to work according to distinct sets of priorities. In so far as historians were concerned with the art of the present, they tended for the most part to view it sceptically, measuring its claims in relation to the different practices and values of the past. For the critics, on the other hand, it was response to the art of the present that tended to motivate any retrospective understanding. In so far as these critics offered historical accounts, they were openly partial narratives serving to support present judgements. 'I am not an historian of art or of anything else', Clive Bell wrote in 1914. 'I care very little when things were made, or why they were made; I care about their emotional significance to us' (Bell 1914, pp.99–100).

The book from which that quotation is taken was published in 1914 under the simple but ambitious title *Art*. It was to be continuously in print for the next three decades and was reissued in revised form in 1949. If there is a single publication that can be taken to represent the ideological character of early Modernist criticism, then this is it. Its telling features include Bell's assertion of the absolute priority of aesthetic value, his disparagement of the neo-classical and renaissance traditions and his preference for styles and periods of art normally thought of as 'primitive', his forthright judgements about individual artists and works of art, and his tendency to make these judgements the bases for sweeping historical generalisations – on the grounds that 'the history of art must be an index to the spiritual history of the race' (ibid., p.97). Above all, the book served to advertise Bell's belief that the one property common to all works of visual art was what he called 'significant form' (ibid., p.11).

The supposed significance of 'significant form' lies in its function as a means of provoking emotion in the spectator. The 'emotional significance' Bell refers to is the sense of value associated with response to the work of art. As he conceives it, this response is evoked not primarily by what it is that is pictured in a given work, but rather by the manner in which that picturing is done. The term 'form' is thus intended to refer not to the pictured subject but rather to the composition and style of the work of art itself – those kinds of factors, in other words, that make the effect of Manet's *Woman with Fans* (fig.16) so different from the effect of Carolus Duran's otherwise very similar *Mlle de Lancey* (fig.17). One way of drawing attention to the difference in effect in this case might be to note the relative self-sufficiency or autonomy of Manet's painting; to observe how much more effective use is made of its surface and how much less reliance is placed upon a kind of 'photographic' copying of the world. Thus, for Bell and other early supporters of modern art, it seemed crucially important not only to observe modern art's divergences from traditional styles but also to stress the modern work's independence from those features of the natural world against which such

styles were conventionally measured. As early as 1890, the painter and theorist Maurice Denis had asserted that the emotional content of art 'springs from the canvas itself, from the flat surface coated with colours, without there being any need to interpose the recollection of another, former sensation (such as that of the natural motif used)'. The significance of 'significant form', it seemed, was to be measured in terms of the achieved self-sufficiency of the work of art. In 1909 Bell's associate Roger Fry concluded an 'Essay in Aesthetics' with the following words: 'We may, then, dispense once for all with the idea of likeness to Nature, of correctness or incorrectness as a test, and consider only whether the emotional elements inherent in natural form are adequately discovered, unless, indeed, the emotional idea depends at any point upon likeness, or completeness of representation' (Fry 1909, in Harrison and Wood 1992, p.86).

To the traditional demand for accuracy of description the supporters of modern art thus answered by pointing to the self-sufficiency of the modern work's formal design. As far as they were concerned, the measure of this self-sufficiency was to be found in the strength of their own responsive emotions. They conceived of this emotion as aesthetic – by which they meant relevant to the experience of art *as art* – to the extent that it was *distinct* from what Bell called 'the emotions of life'. These latter were emotions that the illustrative or descriptive work might indeed arouse, but only at the expense of its aesthetic independence and integrity. As late as 1967 Clement Greenberg distinguished in similar terms between the illustrated subject of a given work of art and its aesthetic effect. It was in the latter, not the former, he stressed, that art's content and indeed its quality were to be found. 'You know that a work of art has content because of its effect. The more direct denotation of effect is "quality"' (Greenberg 1967, in Greenberg IV 1993, p.269). The implication is that both the content and the quality of a given work of visual art are largely independent of its subject matter. A response to the subject matter of a work is not an adequate basis for *aesthetic* judgement, for it is not a proper response to its quality.

There is much to be said in favour of the views thus represented. It is surely indisputable that specific kinds of formal effects are at stake in modern art, that the effects in question are significantly independent of the appearance of things in the world, and that some response to these effects is a necessary condition of understanding the art – of understanding it, that is, *as* art. All other things being equal, to call one person ugly and another attractive is to express a preference for the latter. By the same light, no one in their right minds would prefer a life of grinding poverty to a life of luxurious merry-making. We might acknowledge, however, that a distinctively painted picture of an ugly person could be preferable to a conventionally painted picture of an attractive one, a picture of grinding poverty preferable to a picture of luxurious merrymaking, and in making this acknowledgement we would be allowing for the relative independence of art and of aesthetic values. As Bell put it, 'in the spectator a tendency to seek, behind form, the emotions of life is a sign of defective sensibility always. It means that his aesthetic emotions are weak' (Bell 1914, pp.28–9).

From Fry to Greenberg, the writers who stressed the need to separate aesthetic responses from ordinary desires and appetites and from social or utilitarian considerations were pointing their audience in what they were convinced was the right direction. They were trying to get them to see the art *as art,* and thus as distinct from the world from which its motifs were drawn. Yet we should remember that while this criticism had antecedents in the aesthetic theory of the late eighteenth century, it developed in the modern period from the kind of circumstance we observed in the relationship between the Manet and the Carolus Duran; one in which the effects of different forms of painting could be clearly connected to different ways of experiencing the social and psychological conditions of modern life. What had happened? How had the experience of aesthetic effects become disengaged from the sense of a represented world?

There are two ways in which this question might be answered. The first would involve our noting the tendency of Modernist criticism to autonomise the effects of art and to treat them both as self-sufficient and as self-evident. As Bell wrote, 'To those that can hear Art speaks for itself … To appreciate a man's art I need know nothing whatever about the artist' (ibid., p.98). Taking such utterances as representative, we might say that it is in the work of criticism itself that response to effects is prised loose from all consideration of the conditions under which the works in question were produced. Writers of Bell's persuasion may have been supporting a tendency discernible in the art in question – a tendency to enhance the expressive aspects of visual art and comparatively to reduce the emphasis traditionally placed on descriptive and narrative skills. But it is a limitation in Modernist criticism that these practical processes of enhancement and reduction are not considered as possible forms of response to a larger culture and a social world. For instance, the development recounted in Greenberg's 'Modernist Painting' may not actually rule out the thought that Manet and others chose to paint in a way that would emphasise the literal surfaces of their paintings, and would thus transform the relationship between subject and spectator, but what Greenberg actually tells us in his essay is that *painting* 'oriented itself to flatness' – as if artistic processes were somehow independent of the experiences and actions of those making art. And we might reasonably ask whether it is indeed true that an increasing 'orientation to flatness' is what connects the representative works of modern art. Might it not be the case that Modernist critics were constructing theories simply to justify their own preferences for the relatively flat and formal over the illusionistic and illustrative?

Five years after the publication of 'Modernist Painting', Greenberg's follower Michael Fried reviewed the Modernist position in terms that were clearly dismissive of such suggestions.

Roughly speaking, the history of painting from Manet through Synthetic Cubism and Matisse may be characterised in terms of the gradual withdrawal of painting from the task of representing reality – or of reality from the power of painting to represent it – in favour of an increasing preoccupation with problems

intrinsic to painting itself. One may deplore the fact that critics such as Fry and Greenberg concentrate their attention upon the formal characteristics of the works they discuss; but the painters whose work they most esteem on formal grounds – e.g. Manet, the Impressionists, Seurat, Cézanne, Picasso, Braque, Léger, Mondrian, Kandinsky, Miró – are among the finest painters of the past hundred years. (Fried 1965, in Harrison and Wood 1992, p.770)

Fried's account thus suggests a second form of explanation for the apparent disengagement of aesthetic effects and judgements from the experience of the social world. What he is claiming here is that the priorities of Modernist criticism were *not* in fact imposed upon the development of art as a way of limiting the relevance of realistic considerations. They were rather *required* by that development; they were required, that is to say, by the 'withdrawal of reality from the power of painting to represent it' – a presumably inexorable process beyond the power of either artists or critics to control. The implication is that Modernist criticism's concentration upon formal characteristics is itself realistic, in the sense that it serves to recognise what happen to have been the developing priorities of modern art itself.

Fried's defence of the interests of Modernist criticism was written in 1965 in preface to an exhibition of the recent work of three abstract painters, Kenneth Noland, Jules Olitski and Frank Stella. As he represented it, the nature of the work in question was to be understood in terms of 'the tendency of ambitious art to become more and more concerned with problems and issues intrinsic to art itself' (ibid., p.771). If we take this account on its own terms, then, we should regard Modernist criticism not as a specific form of interpretation of the modern tendency in art, but rather as a form of articulation of the modernist enterprise itself. Indeed, Fried concluded that 'criticism that shares the basic premises of modernist painting finds itself compelled to play a role in its development closely akin to, and potentially only somewhat less important than, that of new paintings themselves' (ibid., pp.773–4). This conclusion serves to remind us that criticism and the making of art may not always be entirely distinguishable activities. The artist, after all, stands before the emerging work as its first critical scrutineer, and the concepts or premises on which that scrutiny is based will be to a greater or lesser extent held in common with other interested parties, such as sympathetic critics.

Whichever form of explanation we favour, it does seem that a consistent tradition of Modernist criticism has both accompanied and served to underwrite the kind of account I sketched out in the previous chapter – one in which the development of modern art appears as a gradual abandonment of the commitment to realism. If the Modernist critic is to be believed this very abandonment has been a necessary condition of aesthetic achievement. As I suggested earlier, we shall return in due course to the matter of modernism's supposed divorce from realism. In the following chapters, however, I mean to inquire further into the connection between modernist art and its attendant criticism, and to continue the account of modern art's development into the twentieth century along the lines that a Modernist criticism might propose.

6

THE PRIMITIVE AND THE PURE

By the time Fry and Bell were writing, Manet's status was secure. It was largely
through their attempts to explain and to defend the virtues of Cézanne's
work that the tenor of their criticism was established. For Fry, Cézanne was
'the great and original genius ... who really started this movement' (Fry 1910,
in Harrison and Wood 1992, p.41). For Bell he was 'the Christopher
Columbus of a new continent of form', a person who 'in so far as one man
can be said to inspire a whole age ... inspires the contemporary movement'
(Bell 1914, pp.207, 199). The principal objections levelled at Cézanne's work
by his many detractors were that it was incompetent, in the sense of failing
accurately to copy the appearance of the world, and that it was lacking in
content. To such objections his defenders responded by claiming of the
modern movement as a whole that it was one in which, in Fry's words, 'the
decorative elements preponderate at the expense of the representative'
(Fry 1910, p.40). Rather than defending Cézanne against the criticisms,
that's to say – for instance by pointing to the extraordinary intensity of his
transcription of naturalistic effects (fig.31) – they dismissed the criticisms as
irrelevant and *unmodern*, stressing the formal vigour and decorative integrity
of the painter's compositions and redefining content in terms of emotional
effect. Following two major exhibitions that Fry initiated in London in 1910
and 1912, the movement that Cézanne was supposed to have inspired came
to be known in England as 'Post-Impressionism'. The name was intended to
designate a specifically artistic movement. It would be no exaggeration to say,
however, that the form of 'emotional significance' associated with the work

of Cézanne was for Fry, Bell and their associates the defining value of modern life as they conceived it.

Though 'Post-Impressionism' was a specifically English formulation, from about 1905 until the outbreak of war in 1914 interest in the idea of a modern movement served to distinguish communities of advanced artists and intellectuals throughout Europe and America. In each of these the modern was associated with forms of departure from naturalistic and classical styles, with rejection of literary and anecdotal forms of subject matter, and with an interest in 'primitive' styles, as supposedly exemplified in tribal or pre-classical sculpture, or in pre-Renaissance Italian art. In most of them the work of Cézanne was accorded a central importance, with his paintings of bathers exercising a particular and widespread fascination. Of the numerous works of art in which these typically modernist themes may be seen as brought practically together the most notorious is Picasso's *Les Demoiselles d'Avignon* (fig.32). In relating this intense and troubling work to Cézanne's there are two points that become immediately clear. The first is that Picasso responded to the strong plastic qualities of Cézanne's figures by enhancing those aspects of his own that read as 'primitive', at the inevitable expense of their naturalism. The second is that he responded to the extraordinary denseness of Cézanne's late figure paintings by narrowing the space between picture plane and background still further in his own work, to the point that his *Demoiselles* threaten to storm the literal surface of the picture and to invade

31
Paul Cézanne

In the Grounds of the Château Noir c.1900

Oil on canvas
90.7 × 71.4
(35¾ × 28¼)
National Gallery,
London

32
Pablo Picasso

*Les Demoiselles
d'Avignon* 1907

Oil on canvas
243.9 × 233.7
(96 × 92)
The Museum of Modern
Art, New York.
Acquired through the
Lillie P. Bliss Bequest

the spectator's world. The consequence of these developments, of course, was further to widen the gap between a modern and a traditional experience of art. By the first decade of the twentieth century the difference of effect that modernism involved had become unmistakable. Modernist art was beginning to look like the product of an entirely separate culture – a culture that did indeed appear intentionally primitive.

Voiced alike by artists and sympathetic critics from the mid-1880s onwards, the sense of common cause with the productions of earlier civilisations, of tribal cultures and of children was an aspect of the modernist critique of the culture of the modern world, and in particular of its growing commercialisation. By the second decade of the twentieth century the proposal to start again from the beginning had become a common slogan among the various European avant-gardes. It was also adopted in implicit justification for forms of work that were as varied as were the local forms of bourgeois culture from which different avant-garde groupings marked out their distance, whether in Moscow, in Munich, in London or in Zurich. The proposal to wipe the slate clean and to start again from the beginning of art may be thought of as a radical form of modernism. To the problem of modern art's relation with the past and its traditions it offered a drastic solution: a clean break. The radicals' rejection of the classical tradition and their sense of kinship with the art of primitives involved a kind of escape

from tradition and from history, for as they conceived it the art of the primitive had neither. To put the point more precisely we might say that the idea of a clean break involved a utopian vision of the future that was both based in a critical perception of the present, and justified by an ideal of human potential for which the supposedly pure and expressive art of the primitive provided trans-historical templates.

If we set alongside this vision the typically modernist belief in the self-sufficiency of artistic form, we can get some sense of the practical and intellectual conditions under which an abstract art came to seem possible, and even, for some, inescapable. It is significant that the earliest experiments in abstract art were accompanied on the one hand by critiques of the decadence and materialism of bourgeois culture, and on the other by claims for the 'spiritual' unity of artistic forms across all ages and cultures. At the

33
Wassily Kandinsky

Cossacks 1910–11

Oil on canvas
94.6 × 130.2
(37¼ × 51¼)
Tate Gallery

34 *right*
Piet Mondrian

*Tree c.*1913

Oil on canvas
100.3 × 67.3
(39½ × 26½)
Tate Gallery

35 *far right*
Piet Mondrian

Composition with Grey, Red, Yellow and Blue, 1920–*c.*1926

Oil on canvas
99.7 × 100.3
(39¼ × 39½)
Tate Gallery

time when he was pursuing his own expressionist art to the point of abstraction (fig.33), the Russian artist Wassily Kandinsky wrote about 'our inner feeling for the primitives ... Just like us, those pure artists wanted to capture in their works the inner essence of things, which of itself brought about a rejection of the external, the accidental' (Kandinsky 1911, in Harrison and Wood 1992, p.87).

Though it was not in itself evidently utopian, the Cubist style that Picasso and Braque developed between 1907 and 1914 may be clearly connected to the priorities of a developing Modernist theory as these were being established at the time. It seemed powerfully to support the idea that the activity on the surface of the painting was dictated less by the actual appearance of the external world than by factors internal to the painting and to the procedures of composition. And it thus seemed to suggest that the deciding factor for the purposes of criticism and evaluation was not the character of the picture's

relationship to the world depicted, but rather the relative coherence and integrity of the decorated surface. Neither Picasso nor Braque ever made an abstract painting, but for many artists exposed to the example of Cubism their work served both as the conclusive evidence of the feasibility, even the necessity, of an abstract art and as a means of practical transition to wholly non-figurative styles. In the words of Kasimir Malevich, one of the major pioneers of abstract art (fig.8), 'in our era of Cubism the artist has destroyed objects together with their meaning, essence and purpose ... Objects have vanished like smoke, for the sake of the new culture of art' (Malevich 1916, in Harrison and Wood 1992, p.174). In the work of the Dutch artist Piet Mondrian this transition from Cubism to abstraction can be followed through succeeding works in which specific themes – trees, church façades,

dune landscapes – are pursued from naturalistic origins, through Cubist forms of analysis (fig.34), until apparently subsumed under the general harmonic principles of abstract configurations (fig.35). Mondrian described these latter as forms of 'pure plasticity'.

For younger artists emerging into independent practice in the second and third decades of the century the means to identify with the modern in art must have seemed clearly prescribed. By the early 1920s there was a substantial literature of modernist criticism and theory to refer to, and within this literature there were clear directives not only to the relevant forms of recent and current practice, but also to the kinds of precedents that were and were not compatible with a modernist disposition. In later life the English sculptor Henry Moore offered some telling observations on his own development during the early 1920s, as he absorbed those precedents, both modern and

'primitive', from which his individual style was to be developed to a point of near-abstraction during the 1930s (fig.36).

> There was a period when I thought that the Greek and Renaissance were the enemy, and that one had to throw all that over and start again from the beginning of primitive art. (Moore 1960, in James 1966, pp.47–8)

and

> Once you'd read Roger Fry the whole thing was there. I went to the British Museum … and saw what I wanted to see. (Moore 1961, in James 1966, p.33)

The same process of absorption and amalgamation can be perceived in the early work of another English artist, the painter Ben Nicholson. In his landscape *Cortivallo Lugano* (fig.37) the motif is interpreted by reference to the landscapes of Cézanne, but it is also given a self-consciously simplified aspect that reflects the artist's taste for so-called 'primitive' forms of picture-making. And at the centre, a red and a white plane are juxtaposed in such a manner as to suggest that a distinctive aesthetic virtue may be found in 'pure' optical effects.

 As the quotation from Kandinsky suggests, interest in the concept of a 'pure' art was a strong factor in the development of forms of abstraction. As proposed by the artist Robert Delaunay in a text of 1912, the purity involved was a 'purity of means' (Delaunay, in Harrison and Wood 1992, p.153). Within the framework of Modernist theory, the pursuit of purity required the purging from art of whatever techniques had previously served to establish connections to literary themes or to evoke a world of objects beyond the art object itself. 'Our world of art has become new, non-objective, pure', Malevich wrote in 1916 (Harrison and Wood 1992, p.174). The decorative integrity of the modern work of art now came to be seen as a form of

36
Henry Moore

*Four-Piece
Composition: Reclining
Figure* 1934

Cumberland alabaster
175 × 45.7 × 20.3
(69 × 18 × 8)
Tate Gallery

37
Ben Nicholson

Cortivallo, Lugano
c.1923

Oil and pencil
on canvas
45.7 × 61 (18 × 24)
Tate Gallery

exemplary design – exemplary, that is to say, of the values of a 'purer' and better life. During the 1920s and 1930s, artists, architects and designers of a purist persuasion thus saw themselves as having common cause in the aesthetic planning of a better world. In the actual practice of art, however, an interest in purity meant the treading of a fine line between refinement and sterility. During the mid 1930s Ben Nicholson and the sculptress Barbara Hepworth between them produced a body of abstract work that was challenging to criticism in that it rendered this distinction both crucial and difficult to explain (figs.38, 39). Hepworth wrote in 1937 that abstract art such as theirs was 'an unconscious manner of expressing our belief in a possible life. The language of colour and form,' she claimed, 'is universal and not one for a special class … it is a thought which gives the same life, the same expansion, the same universal freedom to everyone. The artist rebels against the world as he finds it because his sensibility reveals to him a vision of a world that could be possible.' (Hepworth, in Martin, Nicholson and Gabo 1937, p.116.)

In fact works such as these represent the virtual terminus of modernist development under its purist aspect. The vision of a possible freedom for all had been sustained on the one hand by confidence in the absolute virtue of a liberal culture, and on the other by a belief in the prospect of socialist revolution that was itself fed by a mixture of hearsay and wishful thinking about conditions in the Soviet Union. By the later 1930s the vision had already

become practically unsustainable. Mondrian among others kept faith 'in spite of world disorder' with what he called 'the utility of pure abstract art' (Mondrian, in Martin, Nicholson and Gabo 1937, pp.46, 54). But for the great majority of artists who had still to establish individual styles in the 1930s it must have seemed that a modernist art divested of all possibility of rhetorical power was now likely to remain unnoticed at best. It should not surprise us that the 1930s saw a considerable resurgence of interest in Realist styles, both from the political right, opposed as it was to modernist culture in all its forms, and from those on the political left who regarded Modernist defences of the autonomy of art as expressions of bourgeois élitism.

38
Ben Nicholson

1935 (white relief)
1935

Painted wood
101.6 × 166.4
(40 × 65½)
Tate Gallery

39
Barbara Hepworth

Three Forms 1934

Alabaster
25.7 × 47 × 21.6
(10¼ × 18½ × 8½)
Tate Gallery

7

A Two-Dimensional Manner

Purist abstraction had never been more than one of a number of tendencies that had Cubism as a common antecedent. The Dada and Surrealist movements also looked to Cubism for sanction of certain technical developments. In direct contrast to those who found in Cubism an encouragement to purge the external world from the surfaces of art, however, Dadaists and Surrealists elaborated on the precedent of Cubist collage, using novel forms of montage. The effect was to disturb the decorum of the 'purely visual' with figurative materials and references imported from the wider culture of the modern world. For the most part the artists involved in these movements were disparaged or ignored by Modernist critics, on the predictable grounds that the formal independence of their works is compromised by a reintroduction of 'literary' themes and by a pursuit of effects that are political or topical rather than aesthetic. Greenberg dismissed Surrealism as 'rejuvenated academicism' (Greenberg 1948, p.214). But in fact among the painters acknowledged in Fried's Modernist canon (see p.44) there are two, Picasso and Miró, whose work of the 1920s and 1930s was both central to the Surrealist movement and – as Greenberg himself recognised – indirectly instrumental in the development of a new and thoroughly canonical modernist painting in America during the 1940s. The crucial figure in this latter development was Jackson Pollock. The form of valuation accorded to Pollock's work is also central to a specifically American version of Modernist critical theory. The articulation of this theory was a project that Greenberg had commenced at the end of the 1930s. The wider currency of

Greenberg's work was not really established until the 1950s and early '60s, however, when it became associated with the evident aesthetic power of what he called 'American-type painting', now more commonly labelled Abstract Expressionism. Besides Pollock, the relevant artists included Willem de Kooning, Clyfford Still, Mark Rothko (fig.40) and Barnett Newman (fig.50).

Writing at the beginning of the Second World War, before any of these painters had developed an individual style, and before he was aware of their work, Greenberg had recapitulated the Modernist critical tradition and revised it, taking account of recent developments both in art and in the larger political and cultural world. During the later 1930s and the 1940s the majority of other supporters of modern art continued to associate its development with forms of spiritual and social transformation that it had

40
Mark Rothko

Black on Maroon 1958

Oil on canvas
(266.7 × 365.8
(105 × 144)
Tate Gallery

41
Hans Hofmann

Nulli Secundus 1964

Oil on canvas
213.6 × 131.8
(84 × 52)
Tate Gallery

already in fact and of necessity failed to achieve (it being quite beyond the powers of art to effect such transformations unilaterally). It is to Greenberg's credit that he tried instead to confront the implications of this failure. In his revised understanding of modernist culture, there was no prospect of the unification of art and design; on the contrary, he saw recognition of virtue in art as depending upon 'a fairly constant distinction made between those values only to be found in art and the values which can be found elsewhere'. Writing in the age of the dictators, he was at one and the same time deeply suspicious of popular forms of realism, and convinced that there could be no such thing as a universal and universally accepted modernist culture. Accordingly, he pursued a form of criticism that would systematically exclude any claim in respect of art's purport or value or effectiveness that did not take account of the limits on the power and representativeness of the

medium. Thus, at a time when the global ambitions of the European purists had been shown to be unrealistic, and had even been tainted with the suspicion of totalitarianism, he represented purist abstraction as a specific historical phase in the development of artistic media – a phase significant not of art's potential expansion, but rather of its actual containment within modern bourgeois society. 'The arts ... have been hunted back to their mediums, and there they have been isolated, concentrated and defined ... The imperative comes from history, from the age in conjunction with a particular moment reached in a particular tradition of art' (Greenberg 1940, in Greenberg I 1986, pp.32, 37).

Greenberg's understanding of the modern tradition was largely dictated by his response to Cubism and to the European abstract art that emerged from it. Writing after the end of the war, in 1948, he represented Cubism as 'still

the only vital style of our time, the one best able to convey contemporary feeling, and the only one capable of supporting a tradition which will survive into the future and form new artists.' (Greenberg 1948, in Greenberg II 1986, p.213). By now, however, he was noting a decline among the artists of the original 'cubist generation', Picasso notable among them, and was prompted by the new work of Pollock and other Americans to speculate that 'the main premises of Western art have at last migrated to the United States, along with the center of gravity of industrial production and political power' (ibid., p.215). Greenberg's view of Cubism was in part formed by the teaching of the painter Hans Hofmann, whose long career took him from Munich, via Paris to the New York of the 1930s, and who argued for a 'three-dimensional effect' in painting that yet preserved the 'essential two-dimensionality of the picture plane' (Hofmann 1932, in Harrison and Wood 1992, p.356). As Greenberg envisaged the developed style of Cubism, there were two aspects of particular relevance to the art of the present, one fruitful, one potentially limiting. On the one hand Cubism had shown the way to the more 'purely optical' form of spatial effect that was to be fully developed in Hofmann's work of the 1950s and 1960s: the creation of the illusion of depth not through the modelling of forms in fictitious spaces, but through the mere location and juxtaposition of different planes of colour (fig.41). On the other hand, the regime of flat and decorative planes first employed in Cubist collage had imposed a kind of consistent and restricting geometry on all subsequent abstract art. Picasso's own work had remained both figurative and 'impurely' expressive, and the interacting individuals that populate his pictures still sustain a powerful emotional charge, despite being silhouetted within now straitened compositional spaces. Such works as the *Three Dancers* of 1925 (fig.42) are enlivened by the tension between their decorative formality on

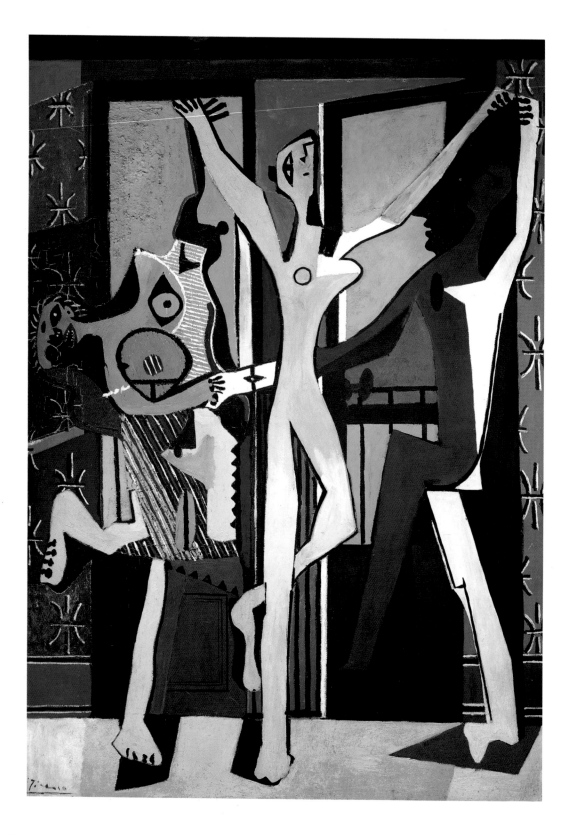

the one hand and their reference to an autobiographical world on the other. By the mid 1930s, however, the shallow and box-like picture space of late Cubism seemed itself to have become an inhibiting convention. Thus, in Greenberg's view, the first problem faced in the 1940s by the painters of the American 'first generation' was 'how to loosen up the rather strictly demarcated illusion of shallow depth [Picasso] had been working within, in his more ambitious pictures, since he closed his "synthetic" Cubist period' (Greenberg 1955, in Greenberg III 1993, p.219).

It was certainly the case that for most of the first-generation American painters the achievement of a workable individual style during the later 1940s entailed the development of an altogether abstract manner, and that in each case the form of abstraction involved was one that left the precedent of Cubism well behind. For Pollock, Rothko and Newman in particular this involved conceiving of composition not as a process of relating separate planes in depth but as the establishment of a continuous surface capable of sustaining the same level of intensity from edge to edge and from top to bottom, however line and colour might be used to qualify it.

It is easy to see how neatly the Greenbergian account can be made to fit the development of Pollock's work in particular – and he was clearly the artist with whose work the writer felt the closest rapport. In the early *Naked Man with a Knife* (fig.43) solidly modelled figures are combined in an expressive late-Realist style with an overall facetting of the picture surface that recalls Picasso's late Cubism of the 1920s and 1930s. Pollock had been deeply impressed by Picasso's *Guernica*, which was on display at the Museum of Modern Art in New York in the late 1930s. Like so many of his contemporaries, he seems to have taken it for proof that a modern style could indeed be used to the ends of public and effective statement. Pollock's picture is uncomfortably dense and clotted, however, as if the extent of his investment in the figurative motif had led him to pack more into his picture than the limitations of the medium can allow or its geometry regulate. In the slightly later *Birth* (fig.44), while the sense of underlying emotional charge is at least as strong, there is less modelling of the represented human form with its monstrous emerging progeny, the line is more fluid and curvilinear, and colour and detail are distributed more evenly across the surface. We might say that the picture plane is allowed to carry very much more of the weight of the painting's effect. Yet the result is still uncomfortable. The surface of the painting is more evenly stressed – so that it appears less like a sculptured relief than the *Naked Man with a Knife* – but the space is still too shallow and too compressed to accommodate so great a measure of both figurative reference and decorative colour and detail. To turn from this work to the later *Black, White, Grey*, however, is to sense an almost palpable relaxation (fig.45). It is not that the absence of figures allows Pollock simply to decorate his surface at will, for the painting does seem to retain some sense of a specific and determining identity. It is rather that this identity has been redefined in terms of the emergent properties of the painting itself.

We might conjecture that the evident formal problems of his earlier work led Pollock to seek a more open form of pictorial space and a more relaxed

42
Pablo Picasso
The Three Dancers
1925
Oil on canvas
215.3 × 142.2
(84¾ × 56)
Tate Gallery

and rhythmical manner of paint application. Accordingly, he modified his technique, using fluid enamels trailed and poured over the canvas in place of tube-colours applied at close quarters with the brush. In the process he both left behind the Cubist armature of his earlier painting and lost the capacity to model and to delineate figurative components. But Modernist criticism recognises the result as more formally and aesthetically satisfactory, and thus in Greenberg's sense more replete with content. A new form of more 'purely optical' space is established, in which the Cubist armature and the figurative components are both shown to be dispensable. From the point of view of Modernist theory in its Greenbergian form, this development in Pollock's work is a consequence of successful self-criticism and is thus progressive. It also serves to demonstrate the self-critical character of modernism as a tendency, in so far as the result of the process is a form of painting in which the essential aspects of the medium are more fully exposed and acknowledged.

In an article published in 1970 Philip Leider, editor of the then-influential magazine *Artforum*, described Pollock's mature work as 'the last achievement of whose status every serious artist is convinced'. Prefacing an essay on the work of the younger American painter Frank Stella, he offered a summation of the Modernist account of Pollock, with explicit acknowledgement to Greenberg and to Michael Fried. '... how his art broke painting's dependence on a tactile, sculptural space; how the all-over system transcended the Cubist

43 *below left*
Jackson Pollock
Naked Man with a Knife
*c.*1938–41
Oil on canvas
127 × 91.4 (50 × 36)
Tate Gallery

44 *below*
Jackson Pollock
*Birth c.*1938–41
Oil on canvas
116.4 × 55.1
(45¾ × 21¾)
Tate Gallery

45 *right*
Jackson Pollock
Untitled (Black, White, Grey) 1948
Oil and enamel on canvas
168 × 84.1
(66⅛ × 33⅛)
Private Collection

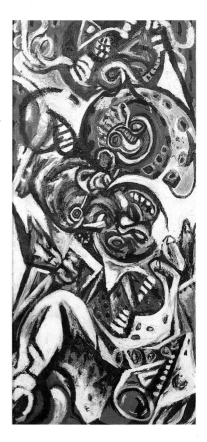

grid; how it freed line from shape, carried abstract art further from the depiction of *things* than had any art before; how it created "a new kind of space" in which objects are not depicted, shapes are not juxtaposed, physical events do not transpire. In short, the most exquisite triumph of the two-dimensional manner. From this appreciation of Pollock,' Leider added, 'have come artists like Morris Louis, Kenneth Noland, Jules Olitski, Helen Frankenthaler and, partially at least, Frank Stella' (Leider 1970, p.44).

The work of Frankenthaler provided a quite specific and revealing link in the chain thus forged. Responding to works by Pollock of 1951 in which enamel paint was allowed to stain directly into unprimed canvas, she experimented with highly fluid paint rapidly brushed onto large absorbent surfaces. Her apparent aim was to combine the scale and spontaneity of Pollock's work with a brilliance and lightness of touch normally only achievable in watercolour. She produced the painting *Mountains and Sea* by this means in the autumn of 1952 (fig.46), registering her own sense of its significance by dating it specifically and conspicuously on the face of the canvas. The Washington-based painters Louis and Noland saw the painting in Greenberg's company on a visit to New York in 1953, and were immediately motivated to experiments of their own, using newly available acrylic paints to achieve more saturated effects of liquid colour than are possible with oils. The resulting work was to be greeted by Greenberg and subsequently by Fried as representing a new high point of modernist achievement (figs.47, 52).

In fact the artists listed by Leider had all received strong support either from Greenberg, or from Fried, or from both during the 1960s. By that time the widespread critical and institutional acclaim given to Abstract Expressionist painting had ensured that considerable interests were at work in identifying a succeeding generation. The acclaim notwithstanding, the public and the market had remained insecure in its response to abstract painting.

The rapid acceptance accorded the work of Jasper Johns, of Robert Rauschenberg and of the Pop artists may be seen as reflecting some relief at the return of graspable reference and imagery. Greenberg responded to the rise of such work with an essay published in 1962. Under the title 'After Abstract Expressionism' he disparaged the 'homeless representation' of Johns's work and sought to establish the abstract painting of Rothko and Newman as indispensable to the continuing enterprise of modernist art (Greenberg 1962, in Greenberg IV 1993, pp.126–34). Introducing the work of Louis, Noland and Olitski a year later, he again implied that an interest in figurative references was necessarily a form of aesthetic impairment, describing the various formal properties of their paintings as 'there, first and foremost, for the sake of feeling, and as vehicles of feeling'. He concluded, 'if these paintings fail as vehicles and expressions of feeling, they fail entirely' (Greenberg 1963, in Greenberg IV 1993, p.153). The implication was that such works as these are the more 'purely' vehicles and expressions of feeling for their elimination of whatever might otherwise serve to mediate the spectator's response to their colour and form, such as recognisable imagery and reference, figurative illusion, or even physical texture (figs.48, 49).

It is a distinguishing feature of the works in question that the techniques by which they were realised allow for a still greater identification of painted area with literal surface than even Pollock achieved, and thus, according to

Modernist theory, a more total acknowledgement of the limits of the medium. The implication of Greenberg's assessment is that it is the self-critical purity of the painter's commitment to the medium that serves as guarantee of directness and value in the emotional content – guarantee that this content is truly *aesthetic*, and not, for instance, anecdotal, or tendentious or merely intellectual. 'It should ... be understood', he wrote in 'Modernist Painting', 'that self-criticism in Modernist art has never been carried on in any but a spontaneous and largely subliminal way ... it has been altogether a question of practice, immanent to practice, and never a topic of theory' (Greenberg 1960, in Greenberg IV 1993, p.91).

8

50
Barnett Newman

Eve 1950

Oil on canvas
238.3 × 172.1
(93¾ × 67¾)
Tate Gallery

MODERNISM AND REALISM REVISITED

In this last-quoted passage we confront what may be considered the central claim of Modernist theory itself. The value of art, it proposes, lies in what we might call the involuntariness or automatism of its aesthetic content and thus in the unquestionable and authentic character of its expressions. Human meanings and values speak through the work of art not in the form in which the artist consciously or theoretically or intellectually apprehends them, nor through the attempt to represent or to advance what we may take to be the proper direction of our history and our societies, for in each of these cases partial interests and investments will be at work, contrary to the dictates of the medium. It is only when the artist works entirely to the dictates of the medium — only when he or she abandons the pursuit of virtue or relevance and submits to the objective standard of *aesthetic* success or failure — that the work of art will testify truthfully to the historical condition and moment of its production, and in that sense become itself a true medium. It is not through correspondence with the appearance of the world, then, that realism is to be achieved, but, on the contrary, through the achievement of an aesthetic autonomy.

In the light of this suggestion we can finally look back to that moment in the later nineteenth century when the interests of modernism and realism appeared to diverge. We can take a somewhat dramatic case in point. Some of Monet's late paintings of lily ponds were painted during the First World War at a place near enough to the Front for the guns sometimes to be audible from his garden. Yet no shadow of a relevant history could be said to fall in

figurative form across his pictures. On the contrary, their celebration of sensory experience seems wholly inconsistent with what we might expect from deliberation on the subject of modern war. If what is required to pass the test of realism is some form of topical picturing, then, such paintings as Monet's must be seen as failing utterly. However, suppose we start from an emotional response and an aesthetic judgement, and that we find the paintings absorbing – both visually complex and formally complete and self-sufficient. To the extent that we do, we might find them expressive of a sense of value in the natural world and in our experience of it. If we then consider that the moment of that expression coincided with a period of war, are we bound to dismiss the result as a form of retreat from the realities of history? Might we not allow the aesthetic integrity of the painting to be an achievement sustained *in the face* of that history, in full awareness of its horrors, and thus potentially a more worthy contribution to what Bell called the 'spiritual history of the race' than the work of someone who believed that in time of war, 'war' alone must be represented?

The claim the Modernist makes is that historical significance is not a simple matter of what art pictures. It is rather to be discovered – or *felt* – in the response of the attentive spectator. At about the time when Barnett Newman commenced the abstract works for which he was to be known – works typically containing a single band or 'zip' of colour on a relatively unmodulated field (fig.50) – he was challenged by the critic Harold Rosenberg to explain what one of his paintings 'could possibly mean to the world'. As he later reported, 'My answer was that *if he and others could read it properly* it would mean the end of all state capitalism and totalitarianism' (Newman 1962, in Harrison and Wood 1992, p.766; italics added). This claim needs to be understood in the context of Newman's belief that 'the meaning must come from the seeing, not from the talking', and that, as regards his own work, 'one of its implications is its assertion of freedom, its denial of dogmatic principles, its repudiation of all dogmatic life' (ibid.).

If there is one lesson that Modernist criticism has had to offer it is that we should indeed attempt to 'read it properly'; that is to say, to regard the work of art on its own terms – which must be formal terms – before submitting it to categorisation, to interpretation or to judgement. 'Make sure the experience is there first', in Greenberg's words (Greenberg 1983). So far as art is concerned the manner of that experience is sensory and emotional as well

as intellectual. The problem is that we do not easily distinguish between the 'emotions of life' and what Bell called the 'emotional significance' of works of art. In the absence of some such distinction our judgements must be nugatory, however, for we are otherwise unable to separate the character of the work from that which we may ourselves have dogmatically attributed to it, mistakenly believing ourselves authorised by the strength of our convictions and feelings.

In earlier describing Matisse's models as locked into modernist decorative schemes, I was intentionally paraphrasing a form of fashionable disparagement of his enterprise – a disparagement that would see him as catering to a form of unreflective bourgeois consumption. It can now be said, however, that to respond attentively to the effects of a work such as the *Woman before an Aquarium* of 1923 (fig.51) is to discover a complexity in Matisse's pictures that is wholly inconsistent with the idea that they are merely consumable. In this case the effect of the composition is to define a form of imaginary spectator who stands on the threshold of the pictorial space, but who has no power to enter it, nor to interrupt the absorbed state of the woman represented. The point is that this effect has to be *felt* before it can properly be brought to bear in interpretation of the picture. Unless we attend to the way in which the picture is composed – the coolness of the colour, the barriers formed by the near edge of the table and the jagged spray of cedar, the white leaf of paper serving to draw the eye down – we will fail to understand its poignancy. Early in the century Matisse himself offered a classic formulation of the relationship between formal composition and expressive effect that lies at the heart of the modernist project.

> Expression, for me, does not reside in passions glowing in a human face or manifested by violent movement. The entire arrangement of my picture is expressive: the place occupied by the figures, the empty spaces around them, the proportions, everything has its share. Composition is the art of arranging in a decorative manner the diverse elements at the painter's command to express his feelings … (Matisse 1908, in Harrison and Wood 1992, p.73)

In a telling footnote to the passage in *Three American Painters* in which Fried referred to reality 'withdrawing from the power of painting to represent it', he described Manet as 'the first painter for whom consciousness itself is the great subject of his art' (Fried 1965, in Harrison and Wood 1992, p.774). In Fried's view Manet was driven to this position by the perception that modern realism entails *self*-awareness. It seems entirely apt to view Matisse's art within a tradition defined in these terms. Through his evident concern with states of consciousness and self-consciousness he achieved an original form of reconciliation of realist aspirations with modernist techniques.

So, finally, can we bridge the broader chronological span of our theme and find relevant terms in which to relate the early and figurative modernism of Manet to the late and fully abstract modernism of, say, Morris Louis? The answer, I think, is that we can, and that the relationship between the two is indeed informative in much the way that Modernist theory would lead us to expect. In the case of Manet's *Woman with Fans*, its distinctness – and in that

51
Henri Matisse

Woman before an Aquarium 1921–3

Oil on canvas
80.7 × 100
(31¾ × 39⅜)
The Art Institute of Chicago. Helen Birch Bartlett Memorial Collection

52
Paul Jenkins

*Phenomena, Yonder
Near* 1964

Acrylic on canvas
294.6 × 161.3
(116 × 63½)
Tate Gallery

53
Morris Louis

Number 99 1959

Acrylic on canvas
25.1 × 360.7
The Cleveland Museum
of Art, Ohio

sense its modernism — was evident from comparison with a nearly
contemporary work by Carolus Duran (figs.16, 17). On the basis of this
comparison, I offered two connected observations. The first was that Manet's
painting engages the spectator more actively with the actual manner and
process of its composition. The second was that this engagement is the
means to stimulate a form of reciprocal imaginative work on the spectator's
part — work which has, as it were, a different social aspect than the somewhat
arch form of role-playing Carolus Duran's picture seems to propose. If we
consider Louis's *Number 99* of 1959 (fig.53) in relation to Paul Jenkins'
Phenomena, Yonder Near of 1965 (fig.52) we shall find that very similar kinds of

discrimination can be made (even without taking into account the differences
in pretension indicated by their respective titles). Louis's painting looks
spontaneously and fluently composed. Beside it the other appears capricious
and arbitrary, its effects open to the incursions and readings of fantasy where
Louis's painting defines and fills out its surface from edge to edge and from
top to bottom. Where the one offers an upright, even and indivisible image,
the other offers to be whatever we choose to make of it: a sunset, an
underwater garden, a dance of the seven veils. Of course, it is *easier* to look at a
sunset than to look at a painting. But then a sunset is nothing new.

9

SCULPTURE, EXCLUSIVENESS AND THE POST-MODERN

Modernist theories of art are largely predicated on the development of painting. It is by the work of Manet, of Cézanne, of Matisse, of the Cubists and of Pollock that Modernist critics have been most continuously exercised. What then of modern sculpture? Should we consider sculpture as conceptually subordinate to painting during the historical currency of modernism, and expect significant change and vitality in the medium to the extent that it is motivated by painting's example? Or should we rather search the history of sculpture for interesting exceptions and anomalies to the Modernist account of art in general?

 The first of these alternatives comes closest to the thesis of developed Modernist criticism itself, which proposes an entirely new form of sculpture grounded in Cubist collage. The second alternative has been the one most favoured by those critical of the Modernist account of modern art and concerned to overthrow the authority of its judgements. A brief review of recent arguments about sculpture and 'three-dimensional work' will thus serve on the one hand to conclude our review of Modernist critical theory and on the other to indicate some points of artistic reference for the concept of Postmodernism.

 In 1958, Greenberg substantially revised an essay that had been first printed nine years previously as 'The New Sculpture', publishing it on this occasion under the title 'Sculpture in Our Time'. In the course of this revision he strengthened his original conception of modern sculpture as an art of *optical* rather than physical or monumental effects. He now proposed that 'sculpture

54
Pablo Picasso

Bottle of Vieux Marc,
Glass, Guitar and
Newspaper 1913

Collage and pen and
ink on blue paper
46.7 × 62.5
(18½ × 24½)
Tate Gallery

– that long eclipsed art – stands to gain by the modernist "reduction" as painting does not', and that in so far as it could provide 'the greatest possible amount of visibility with the least possible expenditure of tactile surface', it stood to achieve new status as 'the representative visual art of modernism' (Greenberg 1958a, in Greenberg IV 1993, p.56). In an essay on collage published in the same year he furnished some indication of how such a sculpture might be both practically and art-historically conceived.

> The original affixed elements of a collage had, in effect, been extruded from the picture plane – the sheet of drawing paper or the canvas – to make a bas-relief. But it was a 'constructed', not a sculpted, bas-relief, and it founded a new genre of sculpture. Construction-sculpture was freed long ago from its bas-relief frontality and every other suggestion of the picture plane, but has continued to this day to be marked by its pictorial origins. Not for nothing did the sculptor-constructor Julio González call it the new art of 'drawing in space'. But with equal and more descriptive justice it could be called, harking back more specifically to its birth in the collage: the new art of joining two-dimensional forms in three-dimensional space (Greenberg, 1958b, in Greenberg IV 1993, pp.64–5).

The development Greenberg had in mind can be traced by considering the relationship between Picasso's collaged *Bottle of Vieux Marc, Glass, Guitar and Newspaper* of 1913 (fig.54), the same artist's constructed *Still Life* of the

following year (fig.55), and González's free-standing *Maternity* of 1934 (fig.57). In turn the example of González's welded sculpture was taken up by the American David Smith (fig.56), whom Greenberg hailed as 'the best sculptor of his generation' in an essay published in 1956 (Greenberg 1956, in Greenberg III 1993, p.277). This was a claim guaranteed to occasion some surprise in England, where the title of 'best sculptor' was widely believed to be reserved for Henry Moore, by virtue of the increasing monumentality and ubiquity of his work. On the other hand younger English artists in the later 1950s were in course of assimilating the implications of Abstract Expressionist painting, shown in London in two highly influential exhibitions

in 1956 and 1959 (respectively, *Modern Art in the United States* and *The New American Painting*, both shown at the Tate Gallery). Given that Smith's work was virtually unknown in England at the time, those who asked themselves questions about the development of sculpture as a modernist art did so largely under the impact of American abstract painting.

Among those English artists thus driven to question the nature of his practice was Anthony Caro, who had worked as an assistant to Moore from 1951 to 1953. Between 1959 and 1960 his style changed dramatically. Densely modelled, and potentially monumental figures in bronze gave way to abstract configurations in cut and welded steel. In works such as *Early One Morning* of 1962 (fig.60) he appeared to fulfil precisely the

conditions Greenberg had prescribed as those on which sculpture might become 'the representative visual art of modernism'. In fact the change in Caro's work coincided with the establishment of direct contacts and indeed relations of close friendship not only with Greenberg, but also with Smith and with Noland. Both Greenberg and Fried responded enthusiastically to what the former called the 'breakthrough' in the sculptor's work (Greenberg 1965, in Greenberg IV 1993, p.205). American painting and English sculpture had come together, it seemed, under the imprimatur of the highest critical authority, to constitute the advanced modernist art of the time. In the years between 1960 and 1967 a successful generation of younger sculptors developed in London in the context of Caro's example, maintaining a fruitful dialogue not only with American painters and writers of a modernist persuasion, but also with those emerging English painters whose concept of a modern tradition had been virtually defined by American forms of abstract art (figs.58,59).

By the later 1960s, however, it was clear that both the practice and the criticism of art were being polarised. One clear symptom of this polarisation was the very recognition that came to be accorded to Modernism as an explicit tendency within criticism; the recognition, that is to say, that the development of art had been subject to a specific and partial form of representation that might itself be represented and criticised. This recognition came the more readily, of course, as Greenberg's influence spread. As his own account of modernism came to be more explicitly theorised, the declarative nature of his judgements and formulations rendered it all the easier to grasp the

character of that larger critical tradition within which he was working. And the more clearly the tradition was characterised, the more vocal the dissent, both from those observers who saw their own interests and preferences downgraded, and from those artists whose practical commitments were sustained by different interpretations of recent history and of the current task in hand.

Among the former were historians who observed that Modernist criticism and its attendant art-historical accounts had tended increasingly to ignore and even to obscure the social conditions of the production of art. In so far as the significance of these conditions was underestimated or misrepresented in those accounts, they asserted, Modernist claims for the meaning and value of art were at best unhistorical and at worst self-serving and false. It was with regard to the revisionist work of such historians that I constructed the sceptical review of modernist developments given at the close of Chapter 4.

Among the second group of dissenters from the Greenbergian account were artists who believed that the Modernist emphasis upon fidelity to the medium had become a prescription for technical conservatism, and that the potential for critically significant development lay not any longer with painting and sculpture but rather with varied forms of what the Minimalist Donald Judd called 'three-dimensional work' (Judd 1965, in Harrison and Wood 1992, pp.809–13). The objections of art historians and dissident artists converged in a revision of the modern canon of art. The later 1950s had seen revival of interest in the Dada movement and particularly in the work of Duchamp. The Surrealist movement gradually regained its political complexion in the art history of the 1960s and 1970s. Interest in Russian Constructivism grew during the same period.

Under these conditions the late-modernist art of the 1960s was subject to

widely varying estimations. The painting of Jules Olitski in particular served as a focus for extreme forms of valuation. To Michael Fried it was made of a 'dialectic ... [that] has taken on more and more of the denseness, structure and complexity of moral experience – that is, of life itself, but life lived as few are inclined to live it: in a state of continuous intellectual and moral alertness' (Fried 1965, in Harrison and Wood 1992, p.773). To the writer Lucy Lippard it was 'visual *Muzak*' (Lippard 1969, in Harrison and Wood 1992, p.849). Estimation of Caro's contemporary work divided along similar lines. By his admirers he was hailed for establishing an equivalent in sculpture to the 'post-painterly abstraction' of Noland and Olitski; for bringing a new and 'optical' form of abstraction to sculpture; for liberating sculptural form from the pedestal and from its legacy of monumentality; for achieving a new

58
John Hoyland

28.5.66 1966

Acrylic on canvas
198.1 × 365.8
(78 × 144)
Tate Gallery

59
Jeremy Moon

Blue Rose 1967

Acrylic on canvas
218.4 × 251.5
(86 × 99)
Tate Gallery

concentration upon what Fried called the 'syntactical' relations between sculptural elements; and above all for using actually substantial components to establish discrete and lyrical effects of the kind normally associated with poetry and music. But to other observers the same body of work appeared as further confirmation that the 'emotional experience' at the heart of Modernist priorities was in essence unsocial. It was experience, that is to say, that was exclusive to a community of privileged individuals. The claim for modernist art's autonomy, it was now suggested, had reduced to a form of special pleading on behalf of this community; a means to protect conceptually fragile work from exposure to the background noise of modernity. Once such work was removed from the 'white cube' of the modernist gallery and required to hold its own in the wider culture, it must be

revealed as merely anodyne. It might be allowed of painting that it could have no plausible existence outside the contained spaces of the home, the gallery and the museum. In fact there were those, wittingly or unwittingly reviving arguments first voiced by Dadaists and Constructivists in the second decade of the century, who claimed that that very containment was significant of painting's inescapable conservatism. But sculpture at least seemed to retain the potential for a kind of public visibility and effectiveness. What good reasons, then, could there be for its restriction to the world in which painting was already isolated? The very concept of sculpture as a 'modernist' art appeared to many as a limitation both on the medium's possible extension into new forms and contexts of display and as a clear sign of the Modernists' final abandonment of any support for the idea of a public culture.

Perhaps the clearest sign of polarisation came in the summer of 1967 with the publication of a special issue on sculpture by the New York-based magazine *Artforum*. The pretext was an exhibition of American sculpture in Los Angeles, in which, significantly, some prominence was accorded to the work of Caro. The major feature was a lengthy essay by Fried, 'Art and Objecthood', in which the work of Caro was treated as exemplary of modernist virtue, alongside the painting of Noland, Olitski and Stella. The remarkable feature of this eulogy was the argument in which it was framed, for the more notable content of Fried's text was its sustained attack on the recent 'three-dimensional work' of those he named as 'Literalists' (now more commonly known as Minimalists), Donald Judd and Robert Morris principal among them. It was central to Fried's argument that 'The concept of quality and value – and to the extent that these are central to art, the concept of art itself – are meaningful, or wholly meaningful, only within the individual arts. What lies *between* the arts is theater' (Fried 1967, p.21). By 'theater' Fried intended reference not to theatre as an art form or set of conventions, but rather to a general form of corrupted sensibility. In the theatrical exchange, the observer's self-awareness and environmental conditions are provided with an animating focus by the encounter with the object. In Fried's view, such exchanges were categorically unlike those forms of relationship between work of art and beholder that modernist theory identified with the act of imagination; relations characterised by states of heightened concentration and by suspension of the contingent sense of self. In his argument, the concept of theatre thus occupies a role very similar to that performed in Clive Bell's work by the 'emotions of life'; recourse to the theatrical mode, that is to say, is the sign of inability or failure to respond aesthetically. In his conclusion, Fried drew attention to what he saw as 'the utter pervasiveness – the virtual universality – of the sensibility or mode of being that I have characterised as corrupted or perverted by theater' (ibid., p.23).

In the view of hindsight, Fried has generally been seen as a somewhat Canute-like figure. Whatever justice is accorded to the evaluative aspects of his argument, the remaining pages of the summer 1967 *Artforum* offered ample evidence of practical dissent from the criteria on which his judgements were based. In the years that followed, artistic modernity became widely associated

60
Anthony Caro

Early One Morning
1962

Painted steel and
aluminium
289.6 × 619.8
× 335.3
(114 × 244 × 132)
Tate Gallery

with forms of art that, if they were 'visual', were most certainly not painting, and, if they were 'three-dimensional', were not easily recognisable as sculpture – not, at least, in any sense acceptable to a Modernist regard.

Our account of modernism may appropriately be closed by the testimony of an artist whose work is intentionally located outside its canons and its protocols.

> I read Michael Fried's essay ... which was a sort of terribly starchy defence of high Modernism, and he spoke of the problem of art that did not follow these modernist precepts as being 'theater'. And I said 'bingo, that's it, that's right'. The art that's important now is a form of theater, and one thing *that* means is that it has to be in the same space as the viewer ... (Rosler 1991)

This concluding discussion leaves us with an open question that may be addressed to the culture of the recent past and the present. What might it mean to say that whatever its virtues may be, and however it may be represented, modernism is no longer *our* culture? Is it the case that what the term modernism picks out is merely a historically specific form of culture – one that has now lost its critical vitality and thus run its course? Or is it the case that modernism stands for a form of demand to which we remain subject? Are we decadent to the extent that we are unable to live up to that persisting moral and intellectual standard with which it is associated in the writing of Fried and others?

BIBLIOGRAPHICAL REFERENCES

BAUDELAIRE, Charles

1859
'Salon of 1859', *Revue Française*, 10 June–20 July 1859: in Jonathan Mayne ed., *Art in Paris 1845–1862; Salons and other Exhibitions Reviewed by Charles Baudelaire*, Oxford 1965, pp.144–222

BELL, Clive

Art, London 1914; 2nd ed. London 1928

DELAUNAY, Robert

1912
'On the Construction of Reality in Pure Painting', *Der Sturm*, Dec. 1912; in Harrison and Wood 1992, pp.152–4

DENIS, Maurice

1890
'Definition of Neo-Traditionism', *Art et Critique*, 23 and 30 Aug. 1890

FRIED, Michael

1965
Three American Painters, Fogg Art Museum, Cambridge, Massachusetts; in Harrison and Wood 1992, pp.769–75

1967
'Art and Objecthood', *Artforum*, Summer 1967, pp.12–23

FRY, Roger

1909
'An Essay in Aesthetics', *New Quarterly*, 1909; in Harrison and Wood 1992, pp.78–86

1910
'Introductory Note' to M. Denis, 'Cézanne', *Burlington Magazine*, Jan. 1910; in Harrison and Wood 1992, pp.40–1

GREENBERG, Clement

1939
'Avant-Garde and Kitsch', *Partisan Review*, Fall 1939; in Greenberg I 1986, pp.5–22

1940
'Towards a Newer Laocoon', *Partisan Review*, July–Aug. 1940; in Greenberg I 1986, pp.23–38

1948
'The Decline of Cubism', *Partisan Review*, March 1948; in Greenberg II 1986, pp.211–15

1955
'American-Type Painting', *Partisan Review*, Spring 1955; in Greenberg III 1993, pp.217–35

1956
'David Smith', *Art in America*, Winter 1956; in Greenberg III 1993, pp.275–9

1958a
'Sculpture in Our Time', *Arts Magazine*, June 1958; in Greenberg IV 1993, pp.55–61

1958b
'The Pasted-Paper Revolution' (reprinted 1961 as 'Collage'), *Art News*, September 1958; in Greenberg IV 1993, pp.61–6

1960
'Modernist Painting', *Forum Lectures*, Washington 1960; in Greenberg IV 1993, pp.85–93

1962
'After Abstract Expressionism', *Art International*, 25 Oct. 1962; in Greenberg IV 1993, pp.121–34

1963
'Introduction to an Exhibition of Morris Louis, Kenneth Noland, and Jules Olitski', *Three New American Painters*, Regina, Jan. 1963; in Greenberg IV 1993, pp.149–53

1965
'Contemporary Sculpture: Anthony Caro', *Arts Yearbook 8*, 1965; in Greenberg IV 1993, pp.205–8

1967
'Complaints of an Art Critic', *Artforum*, Oct. 1967; in Greenberg IV 1993, pp.265–72

1983
'Greenberg on Criticism', TV 29, *A315; Modern Art and Modernism; Manet to Pollock*, Open University, Milton Keynes 1983

I 1986
ed. John O'Brian, *The Collected Essays and Criticism: Vol.I, Perceptions and Judgements 1939–1944*, Chicago 1986

II 1986
—— *Vol.II, Arrogant Purpose 1945–1949*, Chicago 1986

III 1993
—— *Vol.III, Affirmations and Refusals 1950–1956*, Chicago 1993

IV 1993
—— *Vol.IV, Modernism with a Vengeance 1957–1969*, Chicago 1993

HARRISON, Charles and WOOD, Paul

1992
Art in Theory 1900–1990: An Anthology of Changing Ideas, Oxford and Cambridge, Mass.

HEPWORTH, Barbara

1937
'Sculpture', in Martin, Nicholson and Gabo 1937, pp.113–16

HOFMANN, Hans

1932
'On the Aims of Art', *The Fortnightly*, 26 Feb. 1932; in Harrison and Wood 1992, pp.354–7

JAMES, Philip

1966
Henry Moore on Sculpture, London 1966

KANDINSKY, Wassily

1911
'Concerning the Spiritual in Art', Munich 1911; in Harrison and Wood 1992, pp.87–94

LEIDER, Philip

1970
'Literalism and Abstraction – Frank Stella's Retrospective at the Modern', *Artforum*, April 1970, pp.44–51

LIPPARD, Lucy

1969
review of the Whiney Annual, *Hudson Review*, quoted in J. Kosuth, 'Art after Philosophy'; in Harrison and Wood 1992, pp.140–50

MALEVICH, Kasimir

1916
From Cubism and Futurism to Suprematism: The New Realism in Painting, Moscow 1916; in Harrison and Wood 1992, pp.166–76

MARTIN, J.L., NICHOLSON, Ben, and GABO, N.

1937
Circle – International Survey of Constructive Art, London 1937

MATISSE, Henri

1908
'Notes of a Painter', *La Grande
Revue*, Dec.; in Harrison and
Wood 1992, pp.72–8

MOORE, Henry, [Donald
Hall]

1960
'An Interview with Henry
Moore', *Horizon*, vol.3 no.3,
1960; in James 1966, passim

MOORE, Henry, [John and
Vera Russell]

1961
'Conversations with Henry
Moore', *Sunday Times*, 17 and
24 Dec.; in James 1966, passim

NEWMAN, Barnett

1962
'Interview with Dorothy Gees
Seckler, *Art in America*, vol.50,
no.2; in Harrison and Wood
1992, pp.764–6

REDON, Odilon

1922
A Soi-même, journal (1867–1916),
Paris 1922

REWALD, John

1961
The History of Impressionism,
New York 1961

ROSLER, Martha

1991
Interview 24 Nov.; included in
'Art and the Left: The
Critique of Power', TV 23,
*A316: Modern Art, Practices and
Debates*, Open University,
Milton Keynes 1993

RUSKIN, John

1843–60
Modern Painters, 5 vols., London
1843–60

PHOTOGRAPHIC CREDITS

All photographs by Tate Gallery Photographic Department except those listed below.

© 1997 The Art Institute of Chicago. All rights reserved 11, 27, 51; The Ashmolean Museum, Oxford 21; Richard Carafelli 15; © Contemporary Collections of the Cleveland Museum on Art 52; A.C. Cooper Ltd 19; Feilchenfelt Collection, Zurich 20; courtesy Kenneth Noland 49; Walter Klein, Düsseldorf 47; © 1997 The Metropolitan Museum of Art, New York 48; © 1997 The Museum of Modern Art, New York 10, 32; The National Gallery Photographic Department, London 22, 28, 31; National Gallery of Art, Washington 46; Photothèque des Musées de la Ville de Paris 13, 14, 16; Photothèque des Musées de la Ville de Paris / P. Pierrain 17; Musée national d'art moderne, Centre National d'Art et de Culture Georges Pompidou 26; RMN/ Spadem 9; Stedelijk Museum, Amsterdam 6; RMN 23; RMN / J. Schormans 24; Norman Taylor courtesy of The Henry Moore Foundation 25; Waddington Galleries Ltd 45

COPYRIGHT CREDITS

Works illustrated are copyright as follows:

Bonnard, Braque, Derain, González, Kandinski, Miró, Vuillard: © ADAGP, Paris and DACS, London 1997

Hofmann: Courtesy of the André Emmerich Gallery, A Division of Sotheby's

Lewis: © The Estate of Mrs G.A. Wyndham Lewis

Matisse: © Succession Henri Matisse/DACS London

Mondrian: © ABC PMP/ The Estate of Piet Mondrian

Moore: © The Henry Moore Foundation

Nicholson: © Angela Verren-Taunt 1997 All rights reserved DACS

Noland: © Kenneth Noland/DACS, London/ VAGA, New York 1997

Olitski: © Jules Olitski/DACS, London/ VAGA, New York 1997

Picasso: © Succession Picasso/ DACS 1997

Pollock, Rothko: © ARS, NY and DACS, London 1997

Smith: Estate of David Smith/DACS, London/ VAGA, New York 1997

Other works: © The artist or the estate of the artist

INDEX